Buck Moon. Mead Moon. Moon When Cherries Are Ripe. Moon of the Giant Cactus. Tassel Moon. Buffalo Rutting Moon. Ripe Moon. Rain Moon. Trees Broken Moon. Whale Moon. Red Salmon Time Moon. Go Home Kachina Moon. Moon of Claiming. Crane Moon. Moon of the Middle Summer. Hungry Ghost Moon. Lightning. August: Corn Moon. Grain Moon. Dog's Day Moon. Woodcutter's Moon. Sturgeon Moon. Green Corn Moon. Wart Moon. Red Moon. Moon When Cherries turn Black. Moon of the New Ripened Corn. Blackberry Patches Moon. Collect Food for the Winter Moon. Wheat Cut Moon. No Snow on Trails Moon. All the Elk Call Moon. Autumn Moon. Berries Ripen Even in the Night Moon. Summer-time Moon. Lightning Moon. Women's Moon. Dog Days Moon. Dispute Moon. No Snow in the Road Moon. September: Harvest Moon. Full Corn Moon. Fruit Moon. Drying Grass Moon. Barley Moon. Moon When the Calves Grow Hair. Cool Moon. Spawning Salmon Time Moon. Ripe Choke Cherries Moon. Leaf Yellow Moon. Spider Web on the Ground at Dawn Moon. All Ripe Moon. Corn in the Milk Moon. Salmon Spawning Moon. Moon Without a Name. Moon of the Black Calves. Moon When Plums are Scarlet. Big Feast Moon. Little Wind Moon. Moon When Calves Grow Hair. Mulberry Moon. Chrysanthemum Moon. October: Hunter's Moon. Dying Grass Moon. Moon When Water Freezes. Blood Moon. Moon of the Changing Season. Moon When Water Begins to Freeze on the Edge of the Stream. Travel in Canoes Moon. Corn Ripe Moon. Deer Rutting Season Moon. Great Sandstorm Moon. Leaf Fall Moon. Falling River Moon. Falling Leaves Time Moon. Basket Moon. Big Wind Moon. Kindly Moon. Blackberry Moon. Moon When Beading and Quilling is Done. November: Beaver Moon. Frosty Moon. Snow Moon. Moon of the Falling Leaves. Autumn Time Moon. Killing Deer Moon. Corn Harvest Moon. Every Buck Loses His Horns Moon. All Gathered Moon. Stomach Moon. Snowy Mountains in the Morning Moon. Freezing Moon. Initate Moon. No Name Moon. White Moon. Dark Moon. Sassafras Moon. December: The Long Night Moon. Christmas Moon. Christ's Moon. Moon Before Yule. Oak Moon. Moon of the Pop-ping Trees. Her Winter Houses Moon. Night Moon. Cold Month Moon. Ashes Fire Moon. Turning Moon. Middle Winter Moon. Big Freezing Moon. Cold Moon. Twelfth Moon. Bitter Moon. Peach Moon.

January: Winter Moon. Yule Moon. Wolf Moon. Old Moon. Moon of Frost in the Teepee. Cold Weather Moon. Ice Moon. Her Cold Moon. Hoop and Stick Game Moon. Man Moon. Trees Broken Moon. Younger Moon. Limbs of Trees Broken by Snow Moon. Moon when the Little Lizard's Tail Freezes Off. Play Moon. Moon of the Terrible. February: Snow Moon. Hunger Moon. Storm Moon. Trapper's Moon. Moon of Dark-Red Calves. Black Bear Moon. Black Bear Moon. Budding Time Moon. Elder Moon. Wind Moon. Running Season Moon. Wind Moon. Running Season Moon. Frightened Moon. Raccoon's Rutting Season Moon. No Snows on Trails Moon. No Snow in the Road Moon. Moon of Ice. Moon when Trees Pop. Bony Moon. Trapper's Moon. Little Famine Moon. March: Lenten Moon. Full Crust Moon. Sugar Moon. Full Worm Moon. Crow Moon. Full Sap Moon. Fish Moon. Worm Moon. Chaste Moon. Moon of Snow-blindness. Light Snow Moon. Flower Time Moon. Seventh Moon. Big Clouds Moon. Lizard Moon. Little Sandstorm Moon. Wind Strong Moon. Earth Cracks Moon. Moon When Juice Drips from the Trees. Little Wind Moon. Cactus Blossom Moon. Death Moon. Chaste Moon. Sleepy Moon. Moon When Eyes Are Sore From Bright Snow. Big Famine Moon. April: Sprouting Grass Moon. Egg Moon. Seed Moon. Eastern Moon. Planter's Moon. Pink Moon. Fish Moon. Spring Moon. Moon of Grass Appearing. Do Nothing Moon. Deep Water Moon. Ashes Moon. Little Frogs Croak Moon. The Eighth Moon. Leaf Split Moon. Leaf Spread Moon. Grease-wood Fence Moon. Big Wind Moon. Awakening Moon. Growing Moon. Wildcat Moon. Peony Moon. Moon When Geese Return in Scattered Formation. May: Milk Moon. Mother's Moon. Hare Moon. Flower Moon. Corn Planting Moon. Moon When the Ice Goes Out of the Rivers. Ninth Moon. Moon When Horses Get Fat. Moon of the Shedding Ponies. No Name Moon. Moon to Get Ready for Plowing and Planting. Salmonberry Bird Moon. Too Cold to Plant. Dragon Moon. Panther Moon. June: Full Rose Moon Honey Moon. Rose Moon. Flower Moon. Moon of Making Fat. Strawberry Moon. Hot Moon. Moon When the Buffalo Bulls are Rutting. Salmon Fishing Moon. Berry Ripening Season Moon. Ripening Strawberries Moon. Rotten Moon. Corn Moon. Turning Moon. Leaf Dark Moon. Flower Moon. Hoeing Corn Moon. Plant Moon. Turning Back Moon. Moon of Horses. Windy Moon. Lotus Moon. July: Thunder Moon. Hay Moon.

As Long

as the

Moon

Shall Rise

 This book is dedicated to Bob Anderson, my gentle man in the moon.

As Long as the Moon Shall Rise

REFLECTIONS ON THE FULL MOON

ELLEN MOORE ANDERSON, EDITOR

HOLY COW! PRESS
DULUTH, MINNESOTA

Page 106 constitutes an extension of this page.

Cataloging-in-Publications Data

As long as the moon shall rise: reflections on the full moon / edited by Ellen Moore Anderson.
p. cm.
ISBN 0-930100-94-8
I. Moon—Literary collections. I. Anderson, Ellen Moore, 1929–

808.8'032991—dc21 2002024078

10 9 8 7 6 5 4 3 2 1

Publisher's Address:
Holy Cow! Press
Post Office Box 3170
Mount Royal Station
Duluth, Minnesota 55803

Holy Cow! Press titles are distributed to the trade by Consortium Book Sales & Distribution, 1045 Westgate Drive,
Saint Paul, Minnesota 55114. For inquiries, please write us and visit our website: www.holycowpress.org

Let us know peace.
For as long as the moon shall rise,
For as long as the rivers shall flow,
For as long as the sun shall shine,
For as long as the grass shall grow,
Let us know peace.

— A Cheyenne Indian prayer for peace

TABLE OF CONTENTS

EDITOR'S ACKNOWLEDGEMENTS

As Long as the Moon Shall Rise: Reflections on the Full Moon is a collaboration between Jim Perlman, Marian Lansky and myself. Jim is my editor, publisher, guide and friend and I thank him for the vision and thought that he has brought to our work together. The stunning graphics and page layout have been created by Marian, a greatly talented artist. Many people have contributed to the creation of this book, although they may never know the strength and power of their influence. My reverence for the natural world comes from my Irish mother, Beulah Connell, who grew up on a farm in Wisconsin surrounded by Connells and other immigrants up and down the county line. Whatever perseverance I brought to this book over the five years of its creation comes from my German father, Edward Mielke, a beloved family doctor, who was frustratingly methodical but at the same time a brilliant visionary.

Elsie Koplin, my high school Latin teacher, taught me Virgil's *Aenied* and somehow ignited in me an appreciation for the power and beauty of words. In 1978, after a tragedy in the life of my family, Bill Hartfiel made it possible for me to attend a life-changing workshop, where I learned the power of positive affirmations. From Toni Thorstad, a gifted and creative teacher at Nettleton Magnet School and my former colleague, came the idea of exchanging wonderfully creative gifts at the full moon. The anticipation of my daughter-in-law, Sue Morton Moore, at the eventual publication of this book has nurtured my own excitement. The only way I can respond to having been given the gifts of seven beautiful, unique children and their engaging spouses and the caring Anderson family and 20 lovely, energetic grandchildren is to cry out with joy and gratitude. And, finally, this book would never have come to fruition without Bob Anderson, the kind, gentle and loving husband to whom I give my gifts.

What is a full moon gift?

A full moon gift is an expression of love given on the day of the full moon. This beautiful journal offers a way to record the giving of full moon gifts.

Why give a gift at the full moon? The lunar calendar provides a framework or timetable for pausing in the busyness of our lives to slow down and think about another person. Awareness of the moon's phases makes us more sensitive to the rhythms of nature. Thus by connecting two ancient concepts—gift giving and the lunar cycle—a lovely meaningful tradition evolves.

As Long as the Moon Shall Rise is uniquely designed to be touched, looked at, read, written upon and preserved as a cherished journal. With moon images as the unifying theme, the editor's selections of art and writing may evoke smiles, reflections, or whispers of "aha" as we see beauty in a fresh way. The selections range from age-old rituals and myths to contemporary expressions of wonder, from the paintings of Vincent Van Gogh to the haunting metaphors of modern poetry.

Gifts may be given. . .

in so many ways. You may ask a friend or a grandchild or spouse to be your full moon partner. When two people are exchanging gifts, alternate each month. You may choose the deep delight of giving anonymously. Dream of a world in which everyone receives or gives a gift at the full moon! There are an endless number of gifts that you may give. The following are but a few suggestions to spark your own creativity:

☉ *prepare an especially liked food* ☉ *give a luxurious backrub* ☉ *sing an old favorite song* ☉ *go for a special walk* ☉ *set aside time to play a game* ☉ *put on a tape and dance* ☉ *complete one of those "hard to get at" chores* ☉ *lie on your back and look at the stars* ☉ *go biking or antiquing* ☉ *visit a favorite cafe* ☉ *share the beauty of silence* ☉ *discover the uniqueness of a reclusive wild flower* ☉ *explore a state park* ☉ *plant bulbs in the fall* ☉ *arise at dawn to watch a sunrise* ☉ *locate an old photograph and tape it to the kitchen cabinet* ☉ *amaze a shut-in with a May Day basket* ☉ *read aloud from a special author* ☉ *fix a leaky faucet* ☉ *finish a jig saw puzzle* ☉ *plan a treasure hunt with a single rose or truffle at the final clue* ☉ *cook up some homemade chocolate sauce* ☉ *select original art—even if it's a small painting by a child* ☉ *delight children by volunteering at your local school* ☉ *take a cooking class* ☉ *gather groceries and bring to a food shelf* ☉ *install a bird feeder* ☉ *participate enthusiastically in another's favorite hobby* ☉ *volunteer at a favorite nonprofit* ☉ *give the gift of time*

Only you know what might deeply please the one who receives your gift.

The journal provides space for the recording of gifts on acid free paper—and over a period of time—a poignant keepsake book will be created. The book concludes with a three-year listing of full moon dates, a data sheet with technical information about the moon and biographical information about the contributors.

Imagine a millennium in which everyone gives or receives a gift at the time of the full moon!

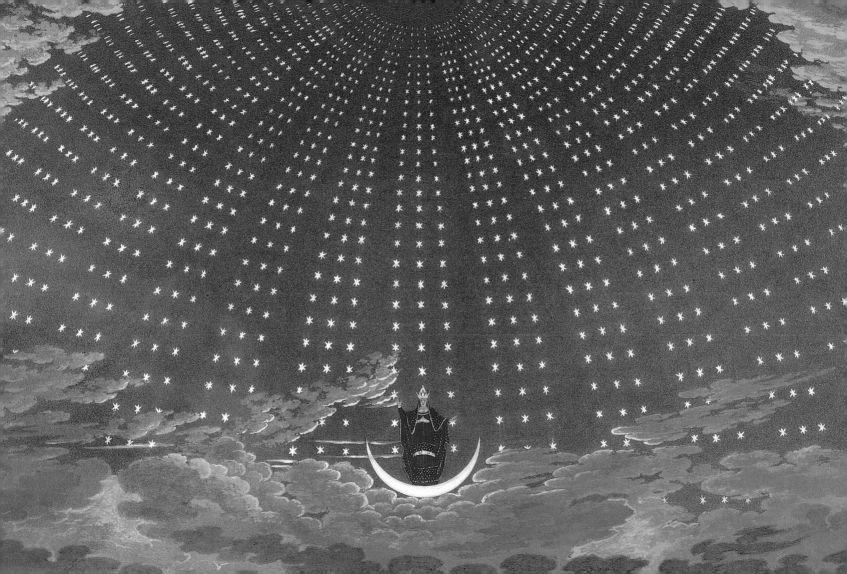

CYCLE I

In the Beginning

Ode

Soon as the evening shades prevail,
The moon takes up the wondrous tale,
And nightly to the listening earth
Repeats the story of her birth;
While all the stars that round her burn,
And all the planets in their turn,
Confirm the tidings as they roll,
And spread the truth from pole to pole.
Joseph Addison

The man who has seen the rising moon
break out of the clouds at midnight, has
been present like an archangel at the
creation of light and of the world.
Ralph Waldo Emerson

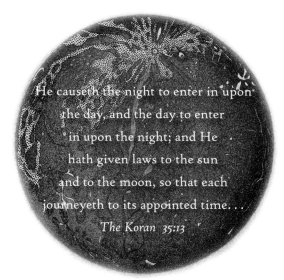

He causeth the night to enter in upon the day, and the day to enter in upon the night; and He hath given laws to the sun and to the moon, so that each journeyeth to its appointed time...

The Koran 35:13

During the time of the ancient Egyptian pharaohs, one of the most important deities was the goddess Isis who was identified with the moon. On one of her statues is this inscription: "I am that which is, has been, and shall be. My veil no one has lifted. The fruit I bore was the sun."

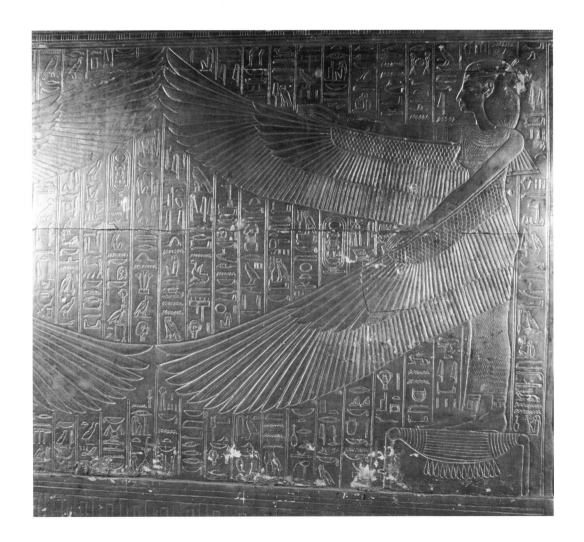

The Creation

And God stepped out on space,
And he looked around and said:
I'm lonely—
I'll make me a world.

And as far as the eye of God could see
Darkness covered everything.
Blacker than a hundred midnights
Down in a cypress swamp.

Then God smiled,
And the light broke,
And the darkness rolled up on one side,
And the light stood shining on the other,
And God said: That's good!

Then God reached out and took the light in his hands,
And rolled the light in his hands
Until he made the sun;
And he set that sun a-blazing in the heavens.
And the light that was left from making the sun
God gathered it up in a shining ball
And flung it against the darkness,
Spangling the night with the moon and stars.
Then down between
The darkness and the light
He hurled the world;
And God said: That's good!
James Weldon Johnson

Full Moon Journal

DATE _____

TO _____ **FROM** _____

GIFT _____

NOTES _____

_____ Like misty moonlight,

watery, bewildering—

_____ our temporal way

Issa

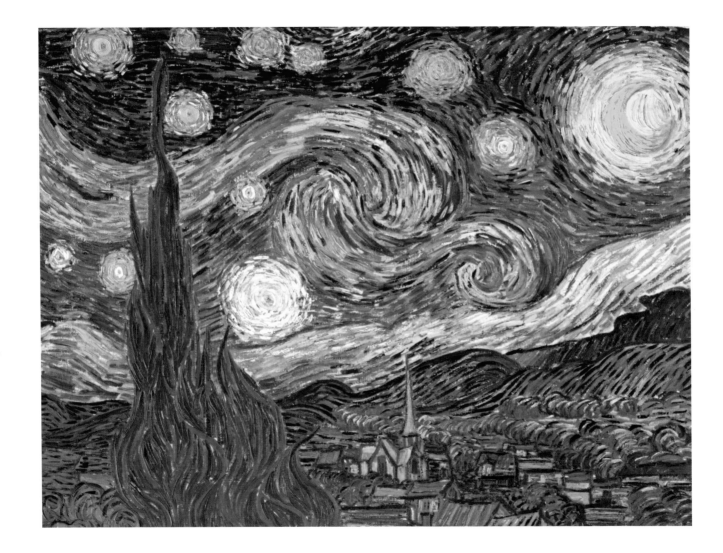

CYCLE 2

The Moon and Her Starry Host

The wakeful nightingale,

She all night long her amorous descant sung;

Silence was pleased; now glow'd the firmament

With living sapphires; Hesperus, that led

The starry host, rode brightest, till the moon,

Rising in clouded majesty, at length

Apparent queen unveil'd her peerless light,

And o'er the dark her silver mantle threw.

John Milton

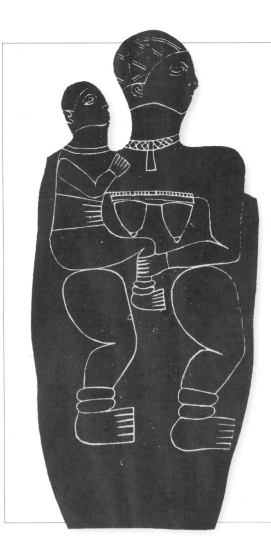

Lullaby

(For a Black Mother)

My little dark baby,
My little earth-thing,
My little love-one,
What shall I sing
For your lullaby?

 Stars,
 Stars,
 A necklace of stars
 Winding the night.

My little black baby,
My dark body's baby,
What shall I sing
For your lullaby?

 Moon,
 Moon,
 Great diamond moon,
 Kissing the night.

Oh, little dark baby,
Night black baby,

 Stars, stars,
 Moon,
 Night stars,
 Moon,

For your sleep-song lullaby.
Langston Hughes

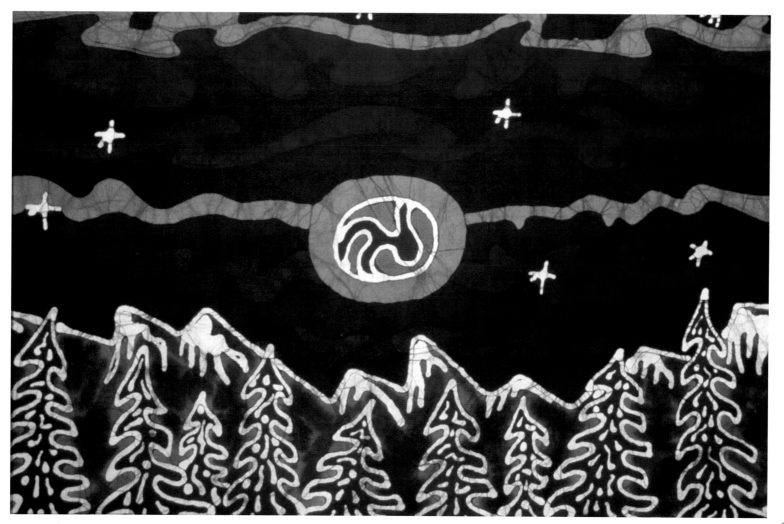

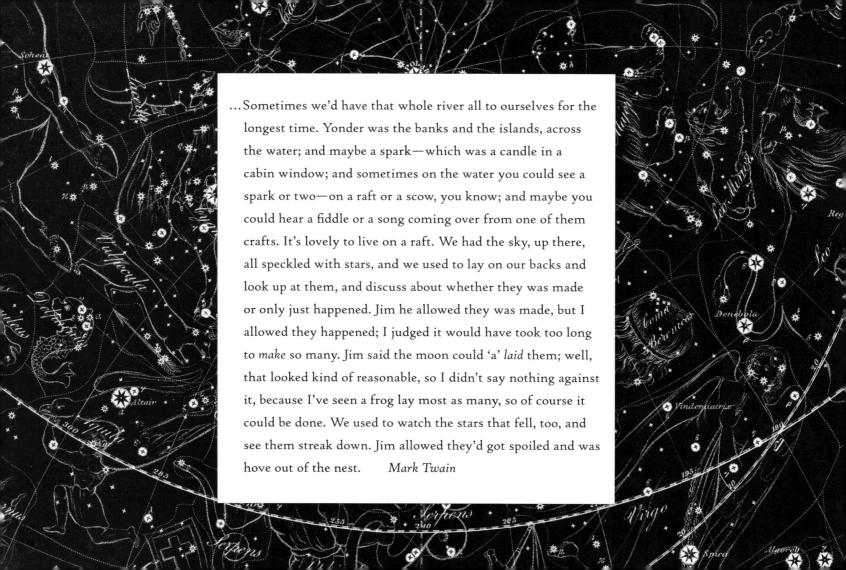

…Sometimes we'd have that whole river all to ourselves for the longest time. Yonder was the banks and the islands, across the water; and maybe a spark—which was a candle in a cabin window; and sometimes on the water you could see a spark or two—on a raft or a scow, you know; and maybe you could hear a fiddle or a song coming over from one of them crafts. It's lovely to live on a raft. We had the sky, up there, all speckled with stars, and we used to lay on our backs and look up at them, and discuss about whether they was made or only just happened. Jim he allowed they was made, but I allowed they happened; I judged it would have took too long to *make* so many. Jim said the moon could 'a' *laid* them; well, that looked kind of reasonable, so I didn't say nothing against it, because I've seen a frog lay most as many, so of course it could be done. We used to watch the stars that fell, too, and see them streak down. Jim allowed they'd got spoiled and was hove out of the nest. *Mark Twain*

Full Moon Journal

DATE

TO _____ FROM _____

GIFT

NOTES

Whatever we wear
we become beautiful
moon-viewing
Chiyo

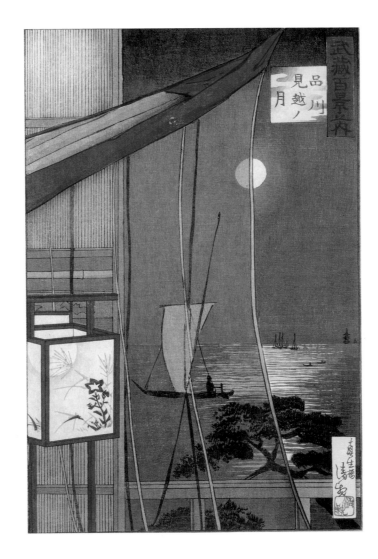

武蔵百景之内

品川
見越ノ
ノ月

CYCLE 3

The Silent Moon

Full Moon

One night as Dick lay fast asleep,
　　　　Into his drowsy eyes
A great still light began to creep
　　　　From out the silent skies.
It was the lovely moon's, for when
　　　　He raised his dreamy head,
Her surge of silver filled the pane
　　　　And streamed across his bed.
So for awhile, each gazed at each—
　　　　Dick and the solemn moon—
Till, climbing slowly on her way,
　　　　She vanished, and was gone.

Walter de la Mare

I gazed upon the cloudless moon,
And loved her all the night,
Till morning came and radiant noon,
And I forgot her light—

No, not forget—eternally
Remains its memory dear;
But could the day seem dark to me
Because the night was fair?
Emily Brontë

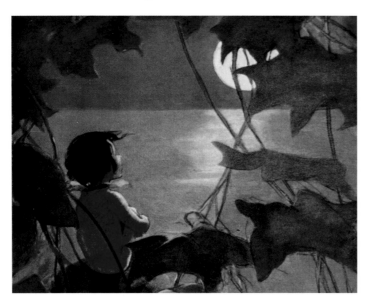

Silver

Slowly, silently, now the moon
Walks the night in her silver shoon;
This way, and that, she peers, and sees
Silver fruit upon silver trees;
One by one the casements catch
Her beams beneath the silvery thatch;
Crouched in his kennel, like a log,
With paws of silver sleeps the dog;
From their shadowy cote the white breasts peep
Of doves in a silver-feathered sleep;
A harvest mouse goes scampering by,
With silver claws, and silver eye;
And moveless fish in the water gleam,
By silver reeds in a silver stream.
Walter de la Mare

Lo, the moon ascending,
Up from the east the silvery round moon,
Beautiful over the house-tops, ghastly, phantom moon,
Immense and silent moon.

Walt Whitman

An Inquiry on a Blustery Night

Inscrutable silent queen,
are you fleeing from that billowing armada of clouds,
or, sedately seated, commanding those ghostly galleons
to sail on out of your realm?

Ellen Moore Anderson

Full Moon Journal

DATE _____

TO _____ FROM _____

GIFT _____

NOTES _____

_____ Clear full moon

_____ The night is very still.

_____ My heart sounds

_____ Like a bell.

Anonymous Folk Song

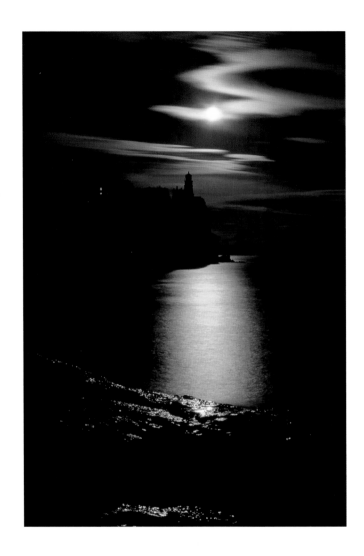

CYCLE 4 — *The Moon and Water*

While Gazing on the Moon's Light

The moon looks
On many brooks,
The brook can see no moon but this.

Thomas Moore

Look—

The moon thumbs through the book of the night.
Finds a lake on which nothing's printed.
Draws a straight line. That's all
it can do.
That's enough.
A thick line. Right to you.
—Look.

Rolf Jacobsen

The Moon is distant from the Sea—
And yet with Amber Hands
She leads Him—docile as a Boy—
Along appointed Sands—

Emily Dickinson

From the Song of Hiawatha

By the shores of Gitche Gumee,
By the shining Big-Sea-Water,
Stood the wigwam of Nokomis,
Daughter of the Moon, Nokomis.
Dark behind it rose the forest,
Rose the black and gloomy pine-trees,
Rose the firs with cones upon them;
Bright before it beat the water,
Beat the clear and sunny water,
Beat the shining Big-Sea-Water...
At the door on summer evenings
Sat the little Hiawatha;
Heard the whispering of the pine-trees,
Heard the lapping of the water,
Sounds of music, words of wonder;
"Minne-wawa!" said the pine-trees,
"Mudway-aushka!" said the water...
Saw the moon rise from the water,

Rippling, rounding from the water,
Saw the flecks and shadows on it,
Whispered, "What is that, Nokomis?"
And the good Nokomis answered:
 "Once a warrior, very angry,
Seized his grandmother, and threw her
Up into the sky at midnight;
Right against the moon he threw her;
'Tis her body that you see there."
 Saw the rainbow in the heaven,
In the eastern sky, the rainbow,
Whispered, "What is that, Nokomis?"
And the good Nokomis answered:
 "Tis the heaven of flowers you see there;
All the wild-flowers of the prairie,
When on earth they fade and perish,
Blossom in that heaven above us"...
Henry Wadsworth Longfellow

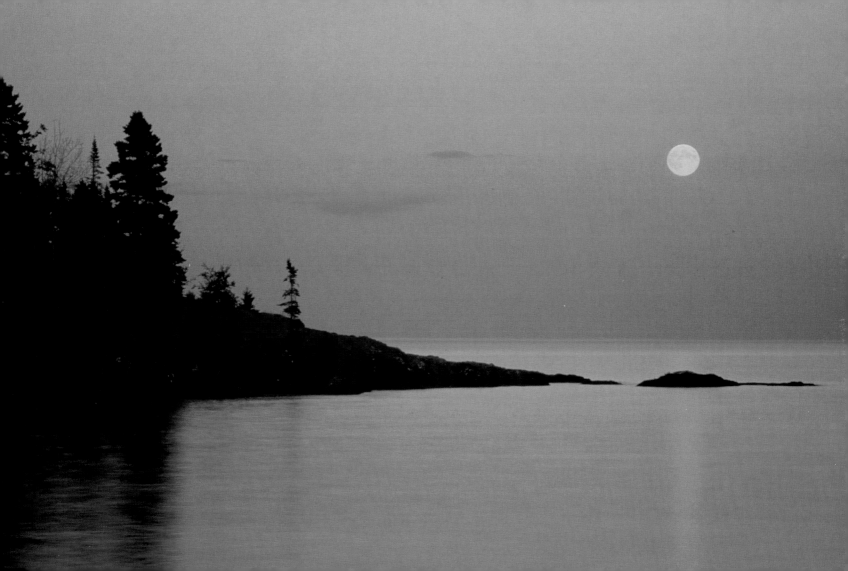

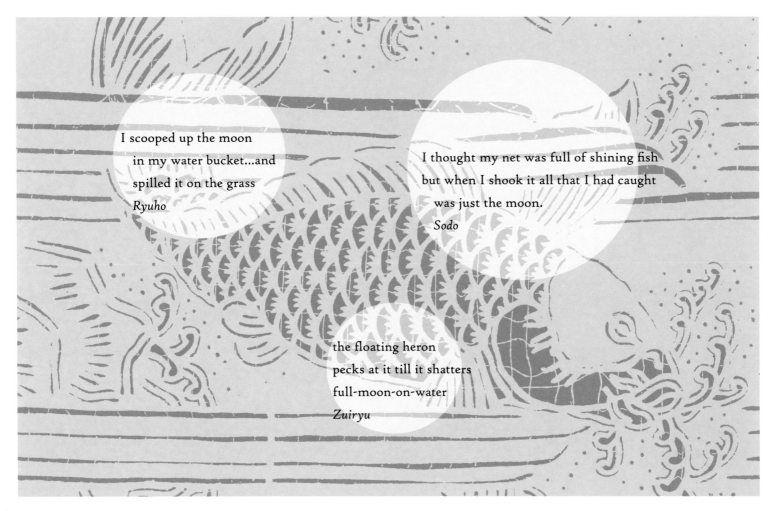

I scooped up the moon
in my water bucket...and
spilled it on the grass
Ryuho

I thought my net was full of shining fish
but when I shook it all that I had caught
was just the moon.
Sodo

the floating heron
pecks at it till it shatters
full-moon-on-water
Zuiryu

Full Moon Journal

DATE _____

TO _____ **FROM** _____

GIFT _____

NOTES _____

Washing the saucepans—
the moon glows on her hands
in the shallow river.
Issa

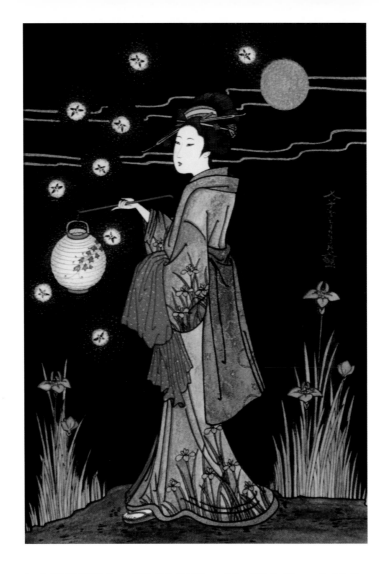

Luna Myths

A Japanese Myth

Once upon a time a woodman and his wife lived on the edge of a forest beneath Mount Fujiyama. They had a comfortable home and a beautiful garden, but no children. One moonlit night, the wife slipped out of the house and prostrated herself before the great mountain with its shining snowcap. She begged Fujiyama to send her a child.

As she prayed, a tiny light appeared high up on the mountain and drifted downward, until it reached the branches of a bamboo. It was a moonchild, sent by the Lady in the Moon. The woodman and his wife were overjoyed.

The moonchild grew up into a beautiful girl, a moon princess, loved dearly by her mortal parents and by all who saw her. The son of the emperor begged for her hand, but the moonchild refused him, saying she was bidden by her true mother, the Lady in the Moon, to return home when she reached twenty years of age.

When the night for her departure arrived, the woodman, his wife and the emperor's son were consumed with grief. The Lady in the Moon sent down a silver beam, and the princess wafted up. All the way, she wept silver tears for those she left behind. As the tears fell, they took wing and floated away everywhere over the land.

Her tears can still be seen on moonlit nights. Some call them fireflies, but those who know the tale know they are the tears of the princess as she searches for those who loved her on earth.

The Moon-Spinners

When you walk at dusk down country roads, you may see three maidens spinning. They are water nymphs. Each has a spindle and is quietly spinning wool that is milk-white, like moonlight. It IS moonlight. In fact, it is the moon itself. Their task is to see that night comes and the world gets its hours of deep darkness to ensure safety for all hunted creatures. Night after night, the maidens spin the moon out of the sky. As you notice the moon getting smaller, the ball of moon-light on the spindles grows larger until finally the moon is gone. There is blessed rest. Then on the darkest night, the maidens go down to the water to wash their wool. As it slips into the water, a strand ripples along the waves until it reaches the horizon and you may see a curved thread of the new moon. When all the wool is washed and wound up into the full white disk in the sky, the moon-spinners start their task again—spinning back the moonlight to give our world its beautiful darkness.

Mary Stewart

The Wolf and the Toad

A wolf once fell madly in love with a toad. One night he set out to catch her and woo her, and prayed to the moon for bright light. The moon obliged. The wolf chased the little toad, and just as he was about to catch her, she made one wild and desperate jump and landed on the moon, where she stayed.

Myth of the Salish Indians of the Pacific Northwest

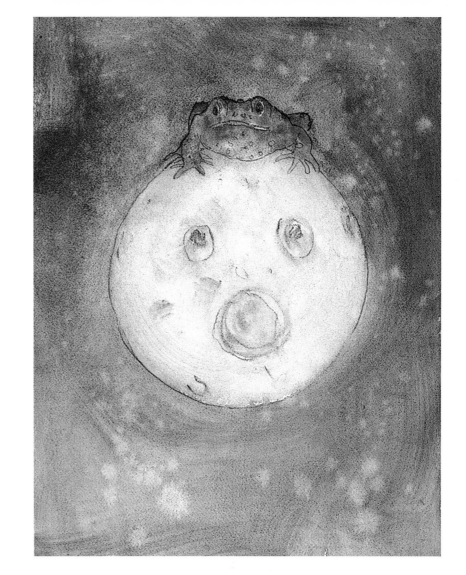

A Chinese Buddhist Allegory

A hare, a monkey, a coot and a fox became hermits in the wilderness after swearing to kill no living things. The god Sakkia decided to try their faith, and appeared before them in the form of a brahmin begging alms. First he approached the monkey, who gave him mangoes. Next he begged the coot, who gave him fish found on the banks of a river. The fox gave him a pot of milk and a dried liguan fruit.

But when the brahmin approached the hare, the hare said, "Friend, I eat nothing but grass, which I think is of no use to you." The brahmin replied that if the hare was a true hermit, he would offer himself as food. The hare immediately agreed to do so, and further agreed to the brahmin's request that he jump into a fire so that the brahmin would not have to kill and dress the hare.

The brahmin lit a fire and the hare climbed on top of a rock and jumped. Just before he reached the flames, the brahmin seized him and revealed himself as the god Sakkia. He placed the hare in the moon so that every living thing in the world could see it as the exemplar of self-sacrifice.

Full Moon Journal

DATE _____

TO _____ FROM _____

GIFT _____

NOTES _____

_____ A Wish

_____ My grumbling wife—

if only she were here!

_____ This moon tonight...

Issa

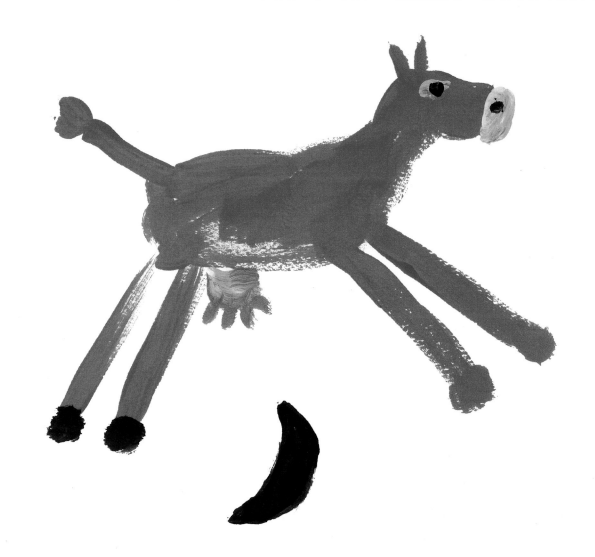

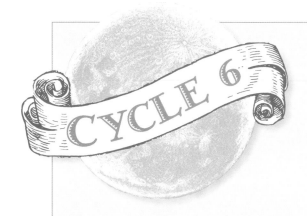

CYCLE 6

The Child's Moon

Wynken, Blynken and Nod

Wynken, Blynken, and Nod one night
 sailed off in a wooden shoe—
Sailed on a river of crystal light,
 into a sea of dew.
"Where are you going, and what do you wish?"
 The old moon asked the three.
"We have come to fish for the herring fish
 That live in this beautiful sea;
 Nets of silver and gold have we!"
 Said Wynken,
 Blynken,
 And Nod.

The old moon laughed and sang a song,
 As they rocked in the wooden shoe,
And the wind that sped them all night long
 Ruffled the waves of dew.
The little stars were the herring fish
 That lived in that beautiful sea—
"Now cast your nets wherever you wish—
 Never afeard are we";
 So cried the stars to the fishermen three:
 Wynken,
 Blynken,
 And Nod.

All night long their nets they threw
 To the stars in the twinkling foam—
Then down from the skies came the wooden shoe,
 Bringing the fishermen home;
'T was all so pretty a sail it seemed
 As if it could not be,
And some folks thought 't was a dream they'd dreamed
 Of sailing that beautiful sea--
 But I shall name you the fishermen three:
 Wynken,
 Blynken,
 And Nod.

Wynken and Blynken are two little eyes,
 And Nod is a little head,
And the wooden shoe that sailed the skies
 Is a wee one's trundle-bed.
So shut your eyes while mother sings
 Of wonderful sights that be,
And you shall see the beautiful things
 As you rock on the misty sea,
 Where the old shoe rocked the fishermen three:
 Wynken,
 Blynken,
 And Nod.
 Eugene Field

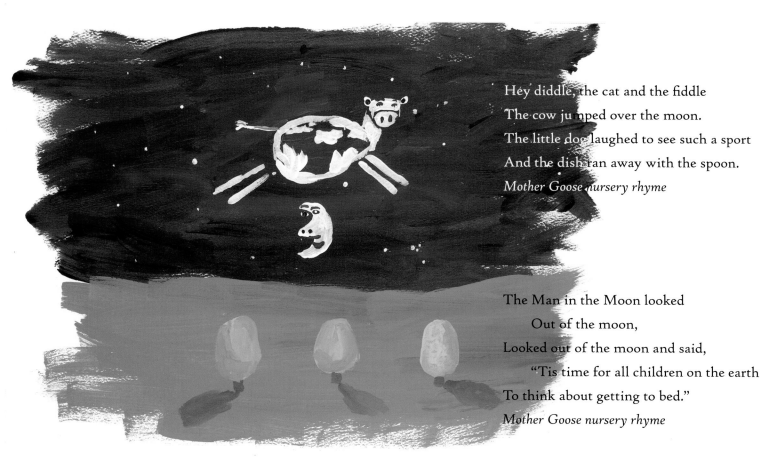

Hey diddle, the cat and the fiddle
The cow jumped over the moon.
The little dog laughed to see such a sport
And the dish ran away with the spoon.
Mother Goose nursery rhyme

The Man in the Moon looked
 Out of the moon,
Looked out of the moon and said,
 "Tis time for all children on the earth
To think about getting to bed."
Mother Goose nursery rhyme

Sofia

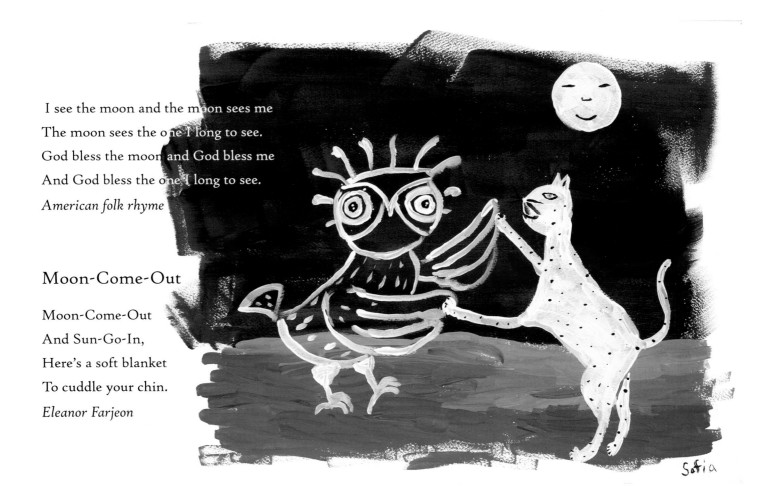

I see the moon and the moon sees me
The moon sees the one I long to see.
God bless the moon and God bless me
And God bless the one I long to see.
American folk rhyme

Moon-Come-Out

Moon-Come-Out
And Sun-Go-In,
Here's a soft blanket
To cuddle your chin.
Eleanor Farjeon

who knows if the moon's
a balloon,coming out of a keen city
in the sky—filled with pretty people?
(and if you and i should

get into it,if they
should take me and take you into their balloon,
why then
we'd go up higher with all the pretty people

than houses and steeples and clouds:
go sailing
away and away sailing into a keen
city which nobody's ever visited,where

always
 it's
 Spring)and everyone's
in love and flowers pick themselves
e. e. cummings

Above the Dock

Above the quiet dock in midnight,
Tangled in the tall mast's corded height,
Hangs the moon. What seemed so far away
Is but a child's balloon, forgotten after play.
T. E. Hulme

Full Moon Journal

DATE

TO _____ FROM

GIFT

NOTES

What a red moon!
And whose is it,
children?

Issa

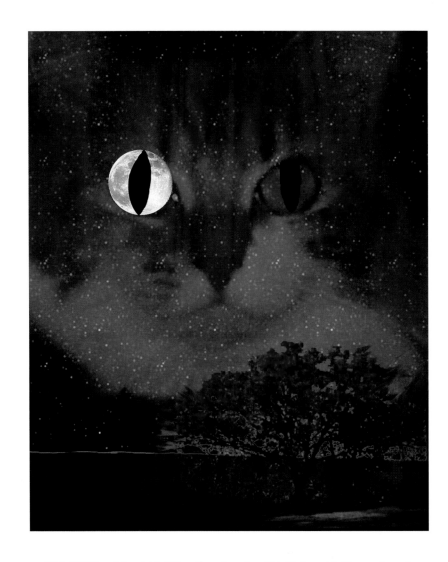

CYCLE 7

Moon Dancing

The Cat and the Moon

The cat went here and there
And the moon spun round like a top,
And the nearest kin of the moon,
The creeping cat, looked up.
Black Minnaloushe stared at the moon,
For wander and wail as he would,
The pure cold light in the sky
Troubled his animal blood.
Minnaloushe runs in the grass
Lifting his delicate feet.
Do you dance, Minnaloushe, do you dance?
When two close kindred meet
What better than call a dance?

Maybe the moon may learn,
Tired of that courtly fashion,
A new dance turn.
Minnaloushe creeps through the grass
From moonlit place to place,
The sacred moon overhead
Has taken a new phase.
Does Minnaloushe know that his pupils
Will pass from change to change,
And that from round to crescent,
From crescent to round they range?
Minnaloushe creeps through the grass
Alone, important and wise,
And lifts to the changing moon
His changing eyes.

William Butler Yeats

Childhood Folklore

Fairy rings are circles of inedible mushrooms that grow naturally in grassy places in Europe, Britain and North America. Folklore holds that if a person stands in a fairy ring under a full moon and makes a wish, the wish will come true. And to see the fairies who are usually invisible except to those with second sight, one must dance around a fairy ring nine times under a full moon. But don't do it on May Eve and All Hallow's Eve, the two major fairy festivals, because the fairies will be offended and carry you off to Elfland.

Full Moon

Off in the twilight hung the low full moon,
And all the women stood before it grave,
As round an altar. Thus at holy times
The Cretan damsels dance melodiously
With delicate feet about the sacrifice,
Trampling the tender bloom of the soft grass.
Sappho

After Many Springs

Now,

In June,

When the night is a vast softness

Filled with blue stars,

And broken shafts of moon-glimmer

Fall upon the earth,

Am I too old to see the fairies dance?

I cannot find them anymore.

Langston Hughes

the moon looked into my window
it touched me with its small hands
and with curling infantile
fingers it understood my eyes cheeks mouth
its hands (slipping) felt of my necktie wandered
against my shirt and into my body the
sharp things fingered tinily my heart life

the little hands withdrew, jerkily, themselves
quietly they began playing with a button
the moon smiled she
let go my vest and crept
through the window
she did not fall
she went creeping along the air

 over houses

 roofs

And out of the east toward
her a fragile light bent gatheringly

e.e. cummings

Full Moon Journal

DATE _____

TO _____ **FROM** _____

GIFT _____

NOTES _____

_____ Moon-in-the-water

turned a white somersault...yes

_____ and went floating off

Ryota

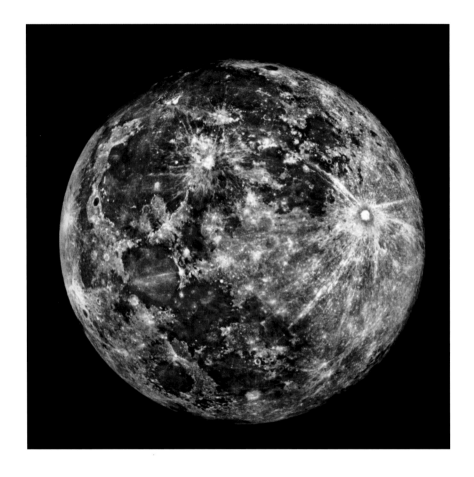

One Small Step

"That's one small step for man, one giant leap for mankind."
Neil A. Armstrong

Treading the soil of the moon, palpating its pebbles, tasting the panic and splendor of the event, feeling in the pit of one's stomach the separation from terra—these form the most romantic sensation an explorer has ever known.
Vladimir Nabokov

"Beautiful! Beautiful! Magnificent desolation!"
Edwin Aldrin, Jr. on joining Neil Armstrong in first walk on the moon, July 20, 1969

Voyage to the Moon

Presence among us,

 Wanderer in our skies, dazzle of silver in our leaves

 and on our waters silver.

 O

silver evasion in our farthest thought—

"the visiting moon" . . . "the glimpses of the moon" . . .

and we have touched you!

 From the first of time,

before the first of time, before the

first men tasted time, we thought of you.

You were a wonder to us, unattainable,

a longing past the reach of longing,

a light beyond our light, our lives—perhaps

a meaning to us . . .

 Now

our hands have touched you in your depth of night.

Three days and three nights we journeyed,

steered by farthest stars, climbed outward,

crossed the invisible tide-rip where the floating dust

falls one way or the other in the void between,

followed that other down, encountered

cold, faced death—unfathomable emptiness . . .

Then, the fourth day evening, we descended,

made fast, set foot at dawn upon your beaches,

sifted between our fingers your cold sand.

We stand here in the dusk, the cold, the silence . . .

and here, as at the first of time, we lift our heads.

Over us, more beautiful than the moon, a

moon, a wonder to us, unattainable,

a longing past the reach of longing,

a light beyond our light, our lives—perhaps

a meaning to us . . .

 O, a meaning!

Over us on these silent beaches the bright

earth,

 presence among us

Archibald MacLeish

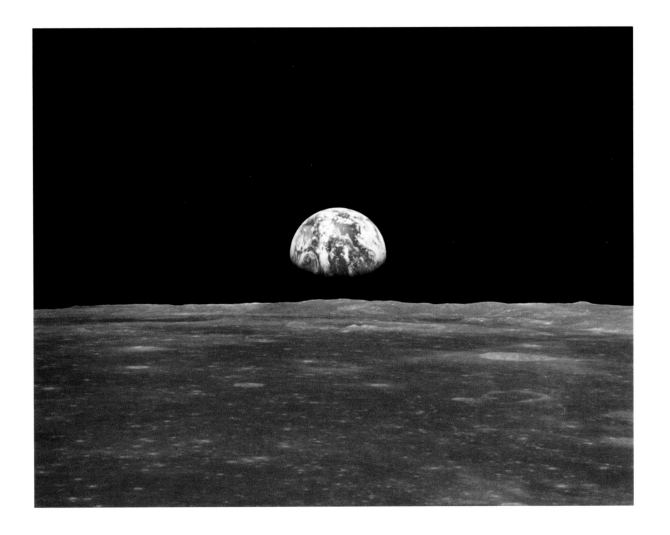

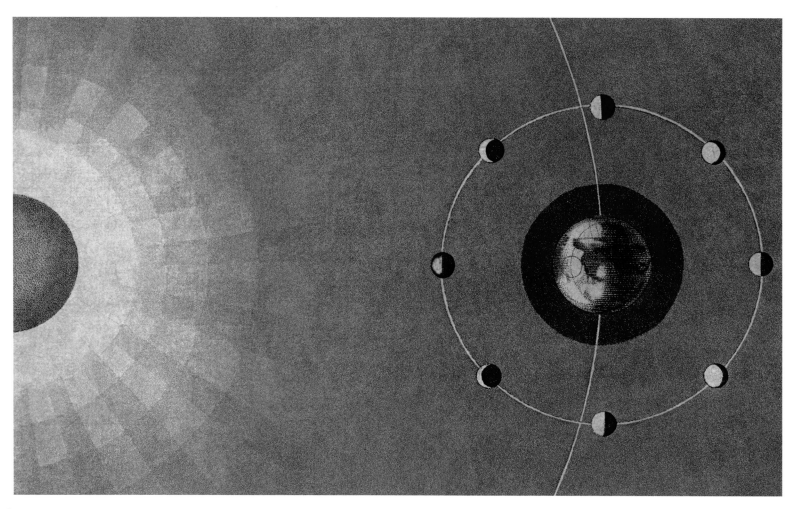

Full Moon Journal

DATE

TO **FROM**

GIFT

NOTES

The way I must enter
leads through darkness to darkness—
O moon above the mountains' rim,
please shine a little further
on my path.
Shikibu

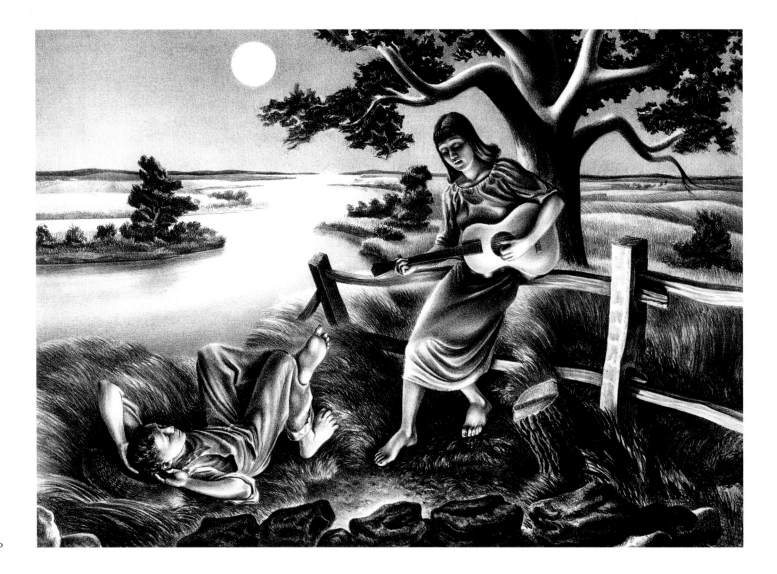

CYCLE 9

Singing Under the Moon

How sweet the moonlight sleeps upon this bank!
Here we will sit, and let the sounds of music
Creep into our ears: soft stillness and the night
Become the touches of sweet harmony.

William Shakespeare

Au clair de la luna,
Mon ami Pierrot,
Prete moi ta plume,
Pour ecrire un mot;
Ma chandelle est morte,
Je n'ai plus de feu,
Ouvre moi ta porte,
Pour l'amour de Dieu.
French folk song

By the light of the moon,
my friend Pierrot,
Lend me thy pen
to write a word;
My candle is out,
I've no more fire,
Open your door to me,
for the love of God.

There's a long, long trail a-winding
Into the land of my dreams,
Where the nightingales are singing
And a white moon beams.
Stoddard King

Wanna cry, wanna croon.

Wanna laugh like a loon.

It's that Old Devil Moon in your eyes.

Burton Lane

Shine on, shine on harvest moon
 up in the sky.
I ain't had no lovin' since
 January, February, June or July.
Snow time ain't no time to
 Stay outdoors and spoon;
So shine on, shine on harvest moon
 For me and my gal.

Jack Norworth

Oh the moonlight's fair to-night along the Wabash,
 From the fields there comes the breath of
 new-mown hay;
Thro' the sycamores the candle lights are gleaming,
 On the banks of the Wabash far away.

Paul Dresser

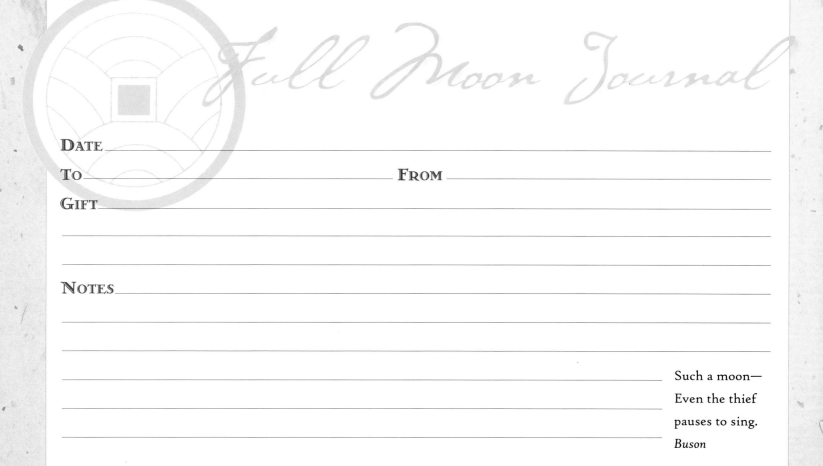

Full Moon Journal

DATE _____

TO _____ **FROM** _____

GIFT _____

NOTES _____

Such a moon—
Even the thief
pauses to sing.
Buson

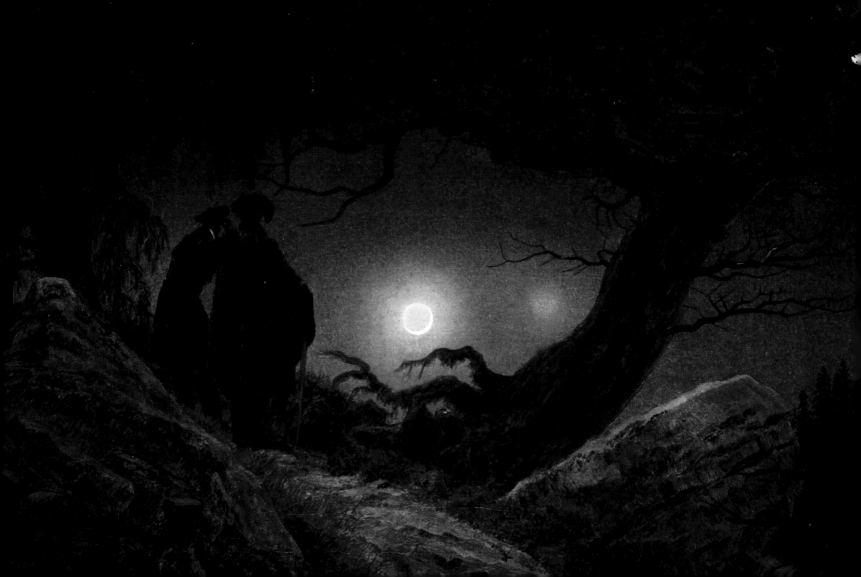

Philosophical Musings

Are we only to look at flowers in full bloom, at the moon when it is clear? Nay, to look out on the rain and long for the moon, to draw the blinds and not to be aware of the passing of the spring—these arouse even deeper feelings.

Men are wont to regret that the moon has waned or that the blossoms have fallen, and this must be so; but they must be perverse indeed who will say, "This branch, that bough is withered, now there is naught to see." In all things it is the Beginning and End that are interesting.

Rather than to see the moon shining over a thousand leagues, it sinks deeper into the heart to watch it when at last it appears toward the dawn. It never moves one so much as when seen in gaps between the trees, pale green over the tops of the cedars on distant hills, or behind the clustering clouds after showers of rain. When it shines bright on the leaves of oak and evergreen, and they look wet, the sight sinks deeply into one's being, and one feels "Oh! for a friend with whom to share this!"

Yoshida Kenko

Ktsi Manido
Great Spirit Moon

Anhaldam mawi kassipalilawalan—
Forgive me for whatever wrong
I might have done to you, my friend.
The New Year's greeting
is on all our lips
as we walk beneath
the Great Spirit's Moon.

Wabikokohas, the snowy owl,
has returned from the winter land.
His feathers make patterns
of life and death.
His wings are the shape of stories.

Now as the drifts pile deep,
the oldest tales remember themselves
on the lips of those who share.
The teachings of the animal people,
those who fly and walk,
those who swim and crawl,
are loaned again for us to hear
in stories older than human breath.

In this season when the earth seemed buried
like the bones of our ancestors,
the fire of those ancient histories
reminds us that everything is waiting,
unseen, but present, gathering strength
to wake again after this moon of rest.

Joseph Bruchac

Grandmother of the Dark

Grandmother of the Dark
Your children Sleep and Death
stay with you in the place of unknown darkness
Let me fly with the Nighthawk
open to all dark places
for the gift of transformation
that comes only from our descent
Jan Hartley Wise

There is something haunting in the light of
the moon; it has all the dispassionateness
of a disembodied soul, and something of its
inconceivable mystery.
Joseph Conrad

If the sea's definition of a shell is the pearl,
And time's definition of coal is the diamond
What is the moon's definition of man.
Kahil Gibran

Although the wind
blows terribly here,
the moonlight also leaks
between the roof planks
of this ruined house.
Shikibu

The youth gets together his materials to build a bridge to the
moon, or, perchance, a palace or temple on earth, and, at length,
the middle-aged man concludes to build a woodshed with them.
Henry David Thoreau

DATE _____

TO _____ **FROM** _____

GIFT _____

NOTES _____

Storehouse burned
Things-to-touch are not;
Oh, the moon-view!

Masahide

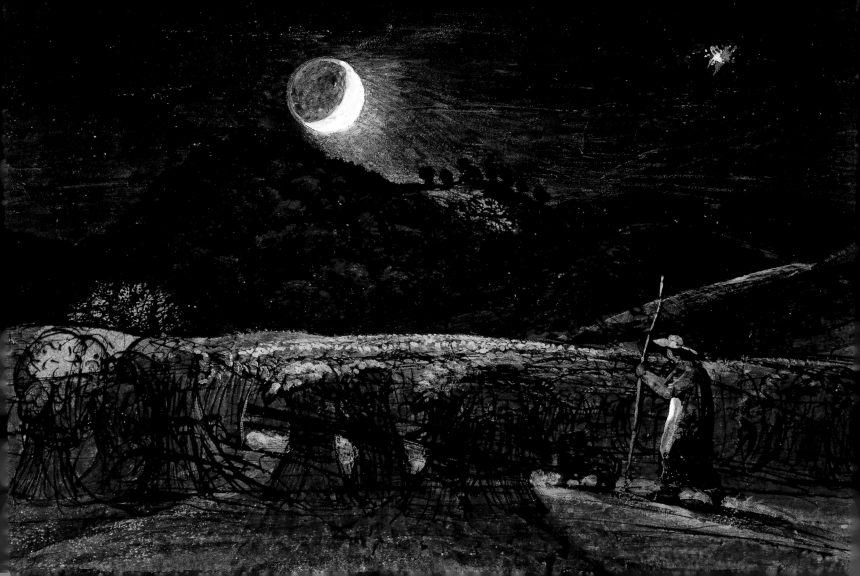

CYCLE 11

Harvest Moon

Harvest Moon

So brilliant a moonshine:
if ever I am born again...
a hill top pine!
Ryota

Autumn

A touch of cold in the Autumn night—
I walked abroad,
And saw the ruddy moon lean over a hedge
Like a red-faced farmer.
I did not stop to speak, but nodded,
And round about were the wistful stars
With white faces like town children.
T. E. Hulme

Harvest moon—
Called at his house,
He was digging potatoes.
Buson

Moon so bright for Love!
Come closer quilt…enfold
My passionate cold!
Sampu

Experimenting…
I hung the moon
on various
branches of the pine
Hokushi

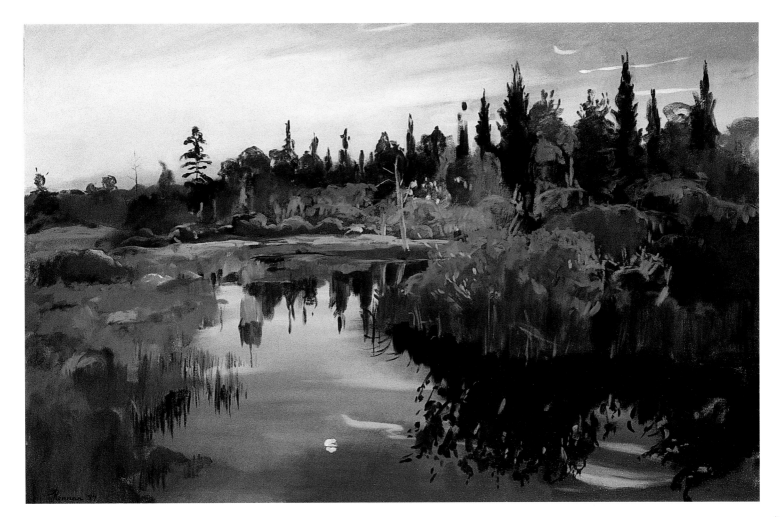

Thy light can visionary thoughts impart,
And lead the Muse to soothe a suffering heart.
Helen Maria Williams

The Harvest Moon

It is the Harvest Moon! On gilded vanes
 And roofs of villages, on woodland crests
 And their aerial neighborhoods of nests
Deserted, on the curtained window-panes
Of rooms where children sleep, on country lanes
 And harvest-fields, its mystic splendor rests.
Henry Wadsworth Longfellow

The crimson Moon, uprising from the sea,
With large delight, foretells the harvest near.
Edward Hovell-Thurlow

Full Moon Journal

DATE _____

TO _____ **FROM** _____

GIFT _____

NOTES _____

_____ Autumn Night

_____ That there is only one
 is unbelievable tonight.
_____ This harvest moon.

 Ryota

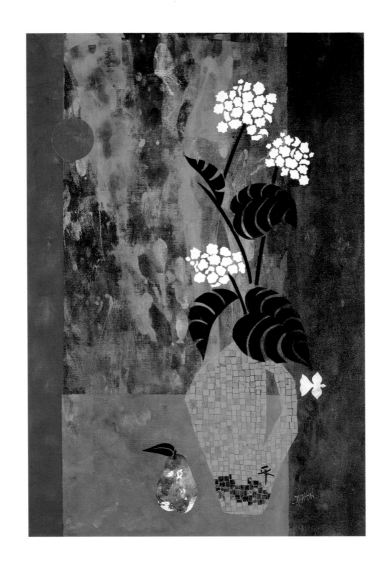

Blossoms

Moon and Apple

When the apple tree blooms
the moon comes often like a blossom,
paler than any of them
shining over the tree.

It is the ghost of the summer,
the white sister of the blossoms who returns
to drop in on us,
and radiate peace with her hands
so that you shouldn't feel too bad when the hard
times come.
For the Earth itself is a blossom, she says,
on the star tree,
pale and with luminous
ocean leaves.

Rolf Jacobsen

Symphony in White

Blossoms on the pear;
 and a woman in the moonlight
 reads a letter there. . .
 Buson

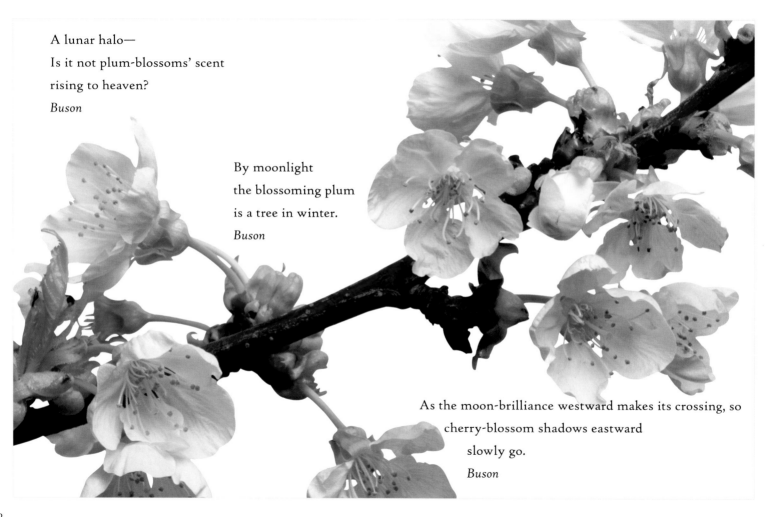

A lunar halo—
Is it not plum-blossoms' scent
rising to heaven?
Buson

By moonlight
the blossoming plum
is a tree in winter.
Buson

As the moon-brilliance westward makes its crossing, so
cherry-blossom shadows eastward
slowly go.
Buson

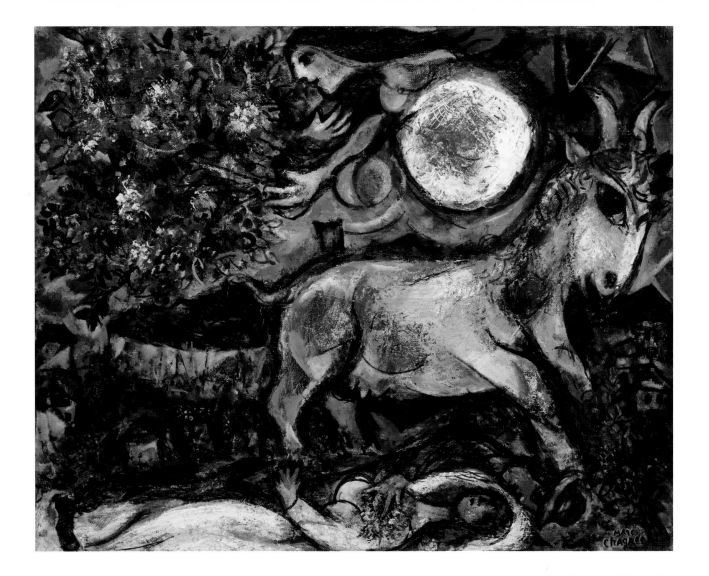

81

Come quickly—as soon as
these blossoms open,
they fall.
This world exists
as a sheen of dew on flowers.
Shikibu

Ten thousand flowers in spring, the moon in autumn,
a cool breeze in summer, snow in winter.
If your mind isn't clouded by unnecessary things
this is the best season of your life.
Wu-Men

The moon like a flower
In heaven's high bower,
With silent delight,
Sits and smiles on the night.
William Blake

Full Moon Journal

DATE

TO _____ **FROM** _____

GIFT

NOTES

I cannot say
which is which:
the glowing
plum blossom is
the spring night's moon.
Shikibu

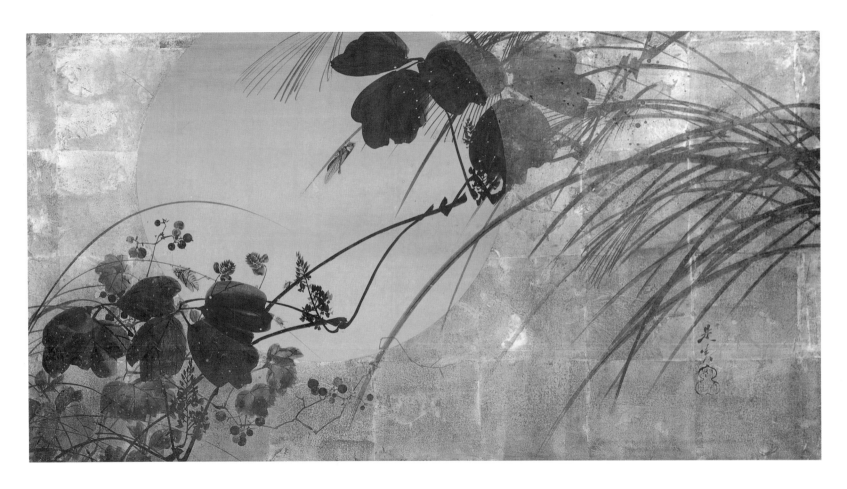

The Classical Moon

Return soul of the sky, candid moon
To the first sphere, shining and beautiful,
And with your customary brilliance restore
The crown of silver to the darkened sky
Claudia Alexander

How beautiful this night!
Heaven's ebon vault,
Studded with stars unutterably bright,
Through which the moon's unclouded grandeur rolls,
Seems like a canopy which love has spread
To curtain her sleeping world.
Percy Bysshe Shelley

The stars are forth, the moon above the tops
Of the snow-shining mountains—Beautiful!
I linger yet with Nature, for the night
Hath been to me a more familiar face
Than that of man; and in her starry shade
Of dim and solitary loveliness
I learn'd the language of another world.

Lord George Gordon Byron

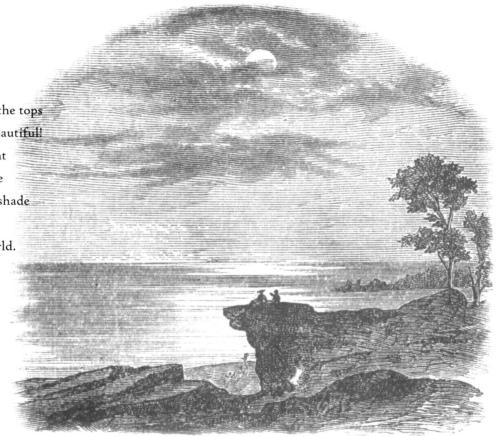

The Highwayman

The wind was a torrent of darkness among the
 gusty trees,
The moon was a ghostly galleon tossed upon cloudy seas,
The road was a ribbon of moonlight over the
 purple moor,
And the highwayman came riding...
 riding... riding...
The highwayman came riding up to the old
 inn-door.
Look for me by moonlight;
Watch for me by moonlight;
I'll come to thee by moonlight, though hell
 Should bar the way.
Alfred Noyes

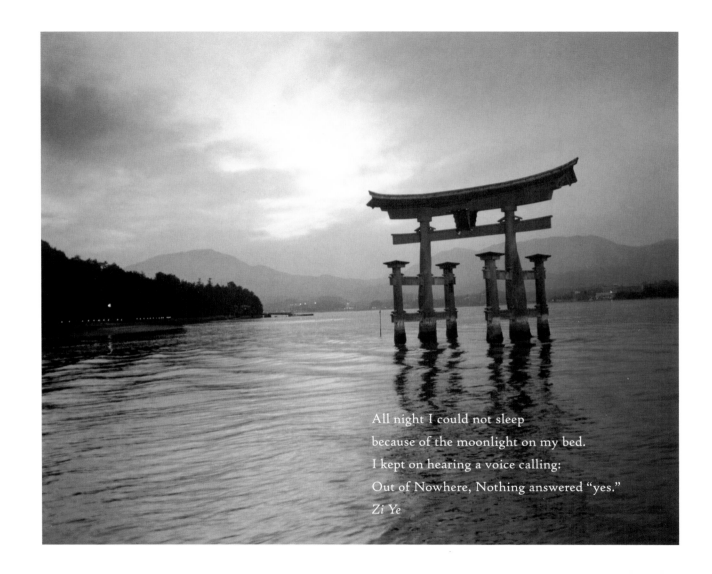

All night I could not sleep
because of the moonlight on my bed.
I kept on hearing a voice calling:
Out of Nowhere, Nothing answered "yes."
Zi Ye

Full Moon Journal

DATE _____

TO _____ FROM _____

GIFT _____

NOTES _____

_____ The clouds come and go,

_____ providing a rest for all

_____ the moon viewers

Bashō

Full Moon Dates 2005 to 2007

Full moon dates are based on Eastern Standard Time. Because of time zone differences, the full moon may occur on a different date in your region.

2005

January	Tuesday	25
February	Wednesday	23
March	Friday	25
April	Sunday	24
May	Monday	23
June	Tuesday	21
July	Thursday	21
August	Friday	19
September	Saturday	17
October	Monday	17
November	Tuesday	15
December	Thursday	15

2006

January	Saturday	14
February	Sunday	12
March	Tuesday	14
April	Thursday	13
May	Saturday	13
June	Sunday	11
July	Monday	10
August	Wednesday	9
September	Thursday	7
October	Friday	6
November	Sunday	5
December	Monday	4

2007

January	Wednesday	3
February	Friday	2
March	Saturday	3
April	Monday	2
May	Thursday	31
June	Saturday	30
July	Sunday	29
August	Tuesday	28
September	Wednesday	26
October	Friday	26
November	Saturday	24
December	Sunday	23

Moon Facts

Maximum distance from Earth (apogee): 252,711 miles

Minimum distance from Earth (perigee): 221,456 miles

Average orbital speed: 287 miles per hour

Orbital direction: counterclockwise

Sidereal orbital period: (time it takes for moon to complete its rotation round the earth and return to its starting position, using a fixed star as a reference point) 27 days, 7 hours, 43 minutes, 11.5 seconds

Synodic orbital period: (the time between one new moon to the next) 29 days, 11 hours, 44 minutes, 2.9 seconds

Distance of one revolution around Earth: 1.4 million miles

Diameter: 2,160 miles (roughly 27% that of Earth)

Circumference: 6,700 miles

Surface temperature range: 266°F (day) to -274°F (night)

Surface area: 15 million square miles

Mass: 81 times smaller than Earth's mass

Surface gravity: 0.154 times that of earth (six times weaker than on Earth)

Saros cycle: (time it takes moon to move to the same position relative to the Sun. Eclipses are predicted using this cycle.) 18 years, 10 days, 7 hours, 42 minutes

TIDES: The tides are a response of the mobile waters of the ocean to the pull of the moon and the more distant sun. In theory, there is a gravitational attraction between every drop of sea water and even the outermost star of the universe... Anyone who has lived near tidewater knows that the moon, far more than the sun, controls the tides. He has noticed that, just as the moon rises later each day by fifty minutes, on the average, than the day before, so, in most places, the time of high tide is correspondingly later each day. And as the moon waxes and wanes in its monthly cycle, so the height of the tide varies. Twice each month, when the moon is a mere thread of silver in the sky, and again when it is full, we have the strongest tidal movements—the highest flood tides and the lowest ebb tides of the lunar month. These are called the spring tides. At these times sun, moon, and earth are directly in line and the pull of the two heavenly bodies is added together to bring the water high on the beaches, and send its surf leaping upward against the sea cliffs, and draw a brimming tide into the harbors so that the boats float high beside their wharfs. And twice each month, at the quarters of the moon, when sun, moon, and earth lie at the apexes of a triangle, and the pull of sun and moon are opposed, we have the moderate tidal movements called the neap tides. Then the difference between high and lower water is less than at any other time during the month.

Rachel Carson

NOTES ON CONTRIBUTORS

JOSEPH ADDISON (1672-1719) was an English politician and writer. He is best known for his essays in *The Spectator* that were designed to improve the morals and manners of the English middle class. Addison was an extremely shy man who was adroit at sensing and profiting from political correctness. He used his poetry and essays as entries into the political world.

EDWIN EUGENE ALDRIN, JR. (1930-) also known as Buzz Aldrin, joined Neil Armstrong in the historic first landing on the moon. But this encounter with fame brought about an excessive use of alcohol, reoccurring bouts of depression and the end of a distinguished military career for this outstanding West Point graduate. As Aldrin struggles to find meaningful life objectives, he has discussed his mental illness openly and candidly.

CLAUDIA ALEXANDER was an 18th century poet.

ELLEN MIELKE MOORE ANDERSON (1929-) lives twenty-five miles north of Duluth, Minnesota on the shores of Lake Superior. For over a decade she and her husband Bob have exchanged and recorded full moon gifts. A former teacher of children with learning disabilities, she is the mother of seven children, an oil painter, and cross-country skier. The royalties from *As Long as the Moon Shall Rise* will be donated to the EMMA Fund, a nonprofit

organization Anderson founded to support projects promoting beauty in the North Shore area of Lake Superior.

NEIL ARMSTRONG (1930-) was the first person to walk on Earth's moon. Aboard his spacecraft were small sections of the wing and propeller of the Wright brothers' airplane that first flew at Kitty Hawk. The world welcomed Armstrong's words when he radioed to mission control on July 21, 1969: "Houston. Tranquillity Base here. The Eagle has landed."

SOFIA ARNOLD (1986-) lives in Viroqua, Wisconsin with older sister Ursula and younger brother Carl. When she was twelve years old she created the whimsical artwork in this journal. Now in high school, she continues her interest in art through the school's computer design team and the creative sewing of her own wardrobe.

MATSUO BASHŌ (1644-1694), was Japan's most famous travel writer in addition to having written time-honored haikus. He wore the black robes of a Buddhist monk and sought a mystical union with nature. Through his journeys that he recorded in six travel books, he attracted new disciples who, in turn, supported him financially. The nitty-gritty challenges of living on the road enabled him to use "vulgar" vocabulary in his classical haikus.

DOUG BEASLEY (1956-) is a gifted Minnesota photographer and teacher. He is the founder and director of Vision Quest Photographic Arts Center which provides photo workshops emphasizing vision and personal expression over camera technique. In his first book *Japan, a Nisel's First Encounter*, Beasley documented how the sacred is incorporated into everyday life of rural Japan. He is currently photographing sacred places around the world. His most recent grant is a McKnight fellowship to photograph disappearing green space in the United States. A lover of late night discussions and very strong morning coffee, Beasley lives in a small wooden house in St. Paul where he works on tending his Japanese gardens.

WILLIAM BLAKE (1757-1827) was a Renaissance-style man who printed his own books and then illustrated them with copperplate engravings and watercolors. He did the engravings for Dante's *Divine Comedy*. From boyhood on, he had mystical visions that he incorporated into a philosophy that proposed that one could experience God directly. He melded together poetry and religion: "The Religions of all Nations are derived from each Nation's different reception of the Poetic Genius, which is everywhere call'd the Spirit of Prophesy."

EMILY BRONTË (1818-1848) wrote only one novel, *Wuthering Heights*, a romantic masterpiece. She and her sisters, Charlotte and Anne, were daughters of a poor Irish clergyman in the small, isolated town of Haworth, Yorkshire. Her mother died when Emily was three. The girls were sent to a harsh boarding school but received a better education than usual for girls at that time. When Emily was twenty-eight, she and her sisters collected poems they had written into a volume of poetry and published them at their own expense. Only two copies sold.

JOSEPH BRUCHAC III (1942-) is one of our best known contemporary Native American storytellers. His writing reflects his mixed ancestry: English, Slovak and Abenaki, a tribe from the Adirondak Mountain area in upstate New York. His motivation for writing comes from a desire to share insights about this fragile, beautiful world which we all have been granted.

YOSA BUSON (1716-1784) is considered one of Japan's three greatest haiku poets, along with Bashō and Issa. He reinvigorated the traditional haiku genre with new descriptive realism. His poetry is pictorial and romantically lyrical. He was also a talented painter, taking pride in honoring classical Japanese sources.

LORD GEORGE GORDON BYRON (1788-1824) inherited his title at the age of ten from his great-uncle. Although the heroes in his poetry are generally swaggering brigands who perform heroic feats, Byron himself was short, somewhat stout, and limped from a clubfoot. Many people find his political and personal adventures as interesting as his writing. His masterpiece, *Don Juan*, is a sixteen-thousand-line poem which, unfinished when he died, expresses his anger at the deceptions and cruelties that men practice on one another.

RACHEL CARSON (1907-1964) wrote a brave controversial book about the dangers of pesticides before there was an environmental movement. Carson was a marine biologist with an impeccable writing style. She was violently assailed with threats of lawsuits, called a hysterical woman, and endured a counterattack by the chemical industry and the Department of Agriculture. *The Silent Spring* (1962) helped lead to restrictions on the indiscriminate use of weed killers and insecticides in many parts of the world.

MARC CHAGALL (1887-1985) was a maverick among the major artists of the twentieth century. He had his own frame of aesthetic and spiritual reference. Calling himself an abstract colorist, he had a mystical love of mankind which he expressed in a child-like style using brilliant colors and objects recalled from his childhood. Many of his subjects float on canvas unbounded by gravity. He inherited ways of thinking from Hasidic Judaism of the Vitebsk, Russian (now Belarus) ghetto of his early years. Most of his adult life was spent in France. Chagall designed stained glass windows as well as sets and costumes for ballets and operas. His murals cover the ceilings of the Metropolitan and Paris opera houses.

UNO CHIYO (1703-1775), a Japanese woman of great physical beauty with a propensity for sensationalism, was considered a seductive femme fatale. Early in her career, the value of her work depended on public interest in her love life. But as she matured, she was regarded as a writer of worth. Her writings reveal the vulnerability of women who have come to recognize the wonder and strength of their own passions and desires.

JOSEPH CONRAD (1857-1924) was born in Russian Poland in Kiev. He left Poland at sixteen to start his maritime career. Arriving in London at the age of twenty unable to speak a word of English, he so mastered his adopted language that he was able to write in English some of the world's greatest novels. Although many of his stories have nautical themes, Conrad was deeply interested in the destructive forces of the human ego.

E(DWARD) E(STLIN) CUMMINGS (1894-1962) was an American poet who generally disregarded the rules of grammar and punctuation to produce a fresh, spontaneous style. He chose to spell his name e. e. cummings. He frequently coined his own words and ran words and sentences together. He is also known for his extensive use of slang, dialect and the rhythms of jazz. Throughout his writing, an underlying theme is a concern with preserving individuality in an age dominated by materialism.

WALTER DE LA MARE (1873-1956) was a talented English writer who is famous for his poetry of childhood. Although he published acclaimed short stories and novels, it is his poetry that reveals his child-like richness of imagination and his vision of a romantic world.

JOHN STOCKTON DEMARTELLY (1903-1979) was a talented lithog-

rapher. He was part of an art movement known as "Regionalism" which celebrated rural American life and values from the Great Depression through World War II. Because his work was representational, he was long viewed as old-fashioned and backward looking by a younger generation of abstract artists. However, new interpretations of his work appreciates what an incisive and perceptive observer he was of his time and place.

EMILY DICKINSON (1830-1886) is now considered one of the greatest American poets. To be a serious poet and a woman was outside the boundaries of nineteenth century norms. She spent most of her life in her home—in fact in her room—in Amherst, Massachusetts. She bound her packets of poems with needle and thread. She wrote over 2,000 poems but only seven were published during her lifetime—and those without her consent. Most of her work was discovered by her sister after her death.

PAUL DRESSER (1859-1906), an actor, songwriter, and music publisher, was one of the outstanding musicians on Tin Pan Alley in New York City. Although his ballads seem quaint now, he was the best-known songwriter in America in the Gay Nineties. Because he was overly generous to his family and friends as well as having problems with his publishing company, he died a poor and broken man.

RALPH WALDO EMERSON (1803-1882) ranks as a leading figure in the thought and literature of American civilization. Despite an early life marked by poverty, sickness and many family deaths,

he developed a humanistic philosophy based on optimism and individualism. Although he was an ordained Unitarian minister, he resigned his pulpit to write and lecture. He favored a new religion founded in nature and fulfilled by direct, mystical intuition of god. In his great essay "Self-Reliance," he wrote: "Nothing is at last sacred by the integrity of your own mind."

ELEANOR FARJEAN (1881-1965) was an American poet, writer, and playwright who is best known for her children's verse and stories. She wrote the words of the well-known hymn "Morning has Broken." Farjean came from a family of successful actors and writers. Although she was very shy and quiet and remained single, she surrounded herself with a circle of gifted, prominent artists.

EUGENE FIELD (1850-1895) has been called the "poet of childhood." He believed children should be brought up in an atmosphere of fancy rather than one of just hard facts. He was a kind, generous man, an adoring father of eight children, and a lover of pleasure and laughter and practical jokes. He did most of his writing in Chicago where there is a beautiful bronze statue showing an angel sprinkling the sand of dreams into the eyes of two sleeping children. Carved on the base are lines from "Wynken, Blynken, and Nod."

CASPAR DAVID FRIEDRICH (1774-1840) was a German painter who was preoccupied by the transformation of the everyday world of people and events under the half-light reflected by the moon and the dramatic emotional charge that moonlight can convey.

Friedrich was of a philosophical, spiritual, and often melancholy turn of mind, and believed that "every true work of art must express a distinct feeling."

OGATA GEKKO (1859-1920) was a Japanese artist who worked as a painter, printmaker and decorator of pottery and lacquer. His favorite subjects were from everyday life scenes. He produced many prints of the Chinese-Japanese War of 1894 including the famous woodblock "Commander Uchida Playing Go."

KAHIL GIBRAN (1883-1931) was a Lebanese writer and painter. He wrote in both English and Arabic and his writing reveals a blending of Oriental and Occidental philosophies. His book, *The Prophet*, remains enormously popular. He was also a serious artist who has portraits and paintings hanging in major galleries.

LORENZ MILTON HART (1895-1943) was an American writer of lyrics for popular songs. He believed his lyrics should be closely integrated with the rhythm of the music and the plot and action of musical comedies. He because famous for his collaborative work with Richard Rodgers.

UTAGAWA HIROSHIGE (1799-1858) was a Japanese master of landscape woodblock prints. Orphaned at the age of twelve, he became known as the artist of rain, snow, and mist. What is universally held among the greatest of all Japanese landscape prints is his "Fifty-Three Stations of the Tokaido" which is a series of prints he made after his first journey down the Tokaido high-way. He lived his entire life in Edo (present day Tokyo.) He was relatively unknown during his lifetime, but since his death from cholera in 1858 his work has gained its great reputation.

HOKUSHI (-1718) was born in Komatsu, Japan. The date of his birth is unknown. His family name is Tachibana Genjiro. He was a disciple of the great haiku master Bashō. One of Hokushi's beloved haikus is:

> *For that brief moment*
> *when the firefly went out . . . O*
> *the lonely darkness.*

EDWARD HOVELL-THURLOW (1781-1829) was a minor English poet who carried the title of baron. Two of his poems are "Moonlight" and "The Song of Britian."

WU-MEN HUI-K'AI (1183-1260) was a Chinese compiler of *The Gateless Gate*, a collection of forty-eight koans or questions which elicit perspectives on life and the nature of self. The material was first published on November 5, 1228 when Wu-Men Hui-k'ai was the head monk at the Lung-hsiang monastery.

LANGSTON HUGHES (1902-1967) was a remarkable Afro-American writer who inspired scores of young writers and left behind a distinguished legacy of literature. In addition to achieving fame as a poet, he was a novelist, columnist, playwright and essayist. He moved many, many times during his childhood—and later in

life traveled extensively abroad. In 1961 he published an innovative book of poems which were meant to be read to jazz accompaniment—*Ask Your Mama: 12 Moods for Jazz.*

T. E. HULME (1883-1917) was an English philosopher, journalist, and poet who died in combat in World War I. He is known for his gift of conveying meaning and emotions through clear, precise images.

ISIS (pre-1300 B.C.) Like all great religions, that of the ancient Egyptians was basically monotheistic permeated by the feeling of a one and only absolute God, an eternal creation with a thousand faces. The most important female deity was Isis, goddess of divine love and generating power. She was identified with the moon. One of her inscriptions states: "I am that which is, has been, and shall be. My veil no one has lifted. The fruit I bore was the sun." When depicted in human form, she has a throne on her head. A carving of her appears on the tomb of King Tutankhamon.

ISSA (1763-1827) whose birth name was Kobayashi Yataro, composed more than 20,000 haikus during his life time. His mother died when he was three and his stepmother was very cold to him. Throughout his life he struggled with family problems. He is most noted for his humorous and simple treatment of his subjects, particularly his affectionate portrayals of creatures normally looked down upon such as fleas and frogs.

ROLF JACOBSEN (1907-1994) was a Norwegian poet whose work has now been translated into thirty languages languages. His poems are sensitive to sound, including silence, that he uses to convey meaning. He felt Norway was less hurt by post-World War II industrialization and was in a unique position to turn to nature to retain a sense of humility and compassion.

JAMES WELDON JOHNSON (1871-1938) was both a lawyer and a poet. In addition to being the first Afro-American to be admitted to the Florida bar, he was the American consul in Nicaragua and Venezuela and a dynamic advocate for civil rights. He is known for his book *God's Trombones* which is a collection of seven sermons recording in free verse the reverent and imaginative beauty of the words of an old Negro preacher. His novel *The Autobiography of an Ex-Colored Man* was first published anonymously.

YOSHIDA KENKO (1283-1350) was a celebrated Japanese Buddhist monk who devoted himself to the pleasures of study. His great work, *Essays in Idleness*, written at a time of political upheaval, is a jumble of ideas, descriptions and aphorisms which remain the accepted authority on Japanese good taste and morals even today. The theme of his work is that life is transient and everything—spring, love, life—has a greater value because it will not last.

KATY KIANUSH (1964-) is an Iranian born artist and illustrator who has been living in England for over 26 years. Her first illustrations for children's poetry books were published in Iran when she was ten years old. Kianush uses a variety of media including pen and ink, conte, watercolors, and acrylics. Her subject matter

ranges from Persian, Japanese and Chinese miniatures, portraits and figure paintings of local and ethnic origins to landscapes. She has won awards in international exhibitions for her work and is the owner of the online gallery and cultural web site "Art Arena."

STODDARD KING (1889-1933) wrote songs popular during World War I. While not mentioning the war, "There's a Long, Long Trail A-Winding" resonated with soldiers in France who were desperately homesick and wanted to reassure their families they would soon be home again.

KOBAYASHI KIYOCHIKA (1847-1915) was a Japanese oil painter whose painting is a synthesis of western and Japanese styles. Later in his life he turned to woodblock printing. He painted many war scenes from the Chinese-Japanese war of 1894 which concluded with the independence of Korea.

BURTON LANE (1913-1997) was one of the most respected American composers of Broadway and Hollywood tunes. He worked closely with lyricist Yip Harburg with whom he wrote his biggest hit, "Finian's Rainbow," a fantasy about an Irishman who steals a leprechaun's pot of gold.

HENRY WADSWORTH LONGFELLOW (1807-1882) was an American poet beloved by his contemporaries. His "Song of Hiawatha" sold more than a million copies during his lifetime, a remarkable record for any book, and especially remarkable for poetry. Today, few critics approve of his sweetly sentimental topics. Longfellow suffered a personal tragedy when, at the height of his success, his adored wife accidentally set her dress on fire. By the time the poet could extinguish the flames, she was fatally burned. "The Cross of Snow," considered his finest poem, gives poignant expression to his grief.

ARCHIBALD MACLEISH (1892-1982) was a powerful poet, playwright, journalist, lawyer, statesman, and professor. A three-time winner of Pulitzer prizes, his deep concern with human suffering might be summed up with this quote from him: "To face the truth of the passing away of the world, and make song of it, make beauty of it, is not to solve the riddle of our mortal lives but perhaps to accomplish something more."

CHARLEEN MARTIN (1945-) is an artist who uses mixed media mosaic collage. Her work is currently published and sold worldwide and is held in both private and public collections throughout the United States and Europe. The image of the sun or moon, which represents the "circle of life," is in all her artwork. She lives in Coeur d'Alene, Idaho.

MIZUTA MASAHIDE (1657-1723) was a Japanese writer.

JOHN MILTON (1608-1674), one of the most respected figures in English literature, was a man of conflicting passions. He was a Puritan with an implacable moral austerity but at the same time was sensuous and full of pride and ambition. That he was quite unkind to his first wife and three daughters is one of the para-

doxes of the man. When he became aged and blind and his public career was over, he turned to his dream of writing a national epic. In 1667 the beautiful, sublime *Paradise Lost* was published.

ERIC J. MAIORANA (1971-) has been making batiks for a decade. In 1996 he founded Peak to Peak Batiks. Maiorana lives in a small mountain town called Ward. His workshop is down the canyon in Boulder, Colorado. Inspired by music, animals and the diversity of the planet, he has created numerous designs. He supplies batik t-shirts to bands, restaurants and shops in the Boulder area as well as retailing off his web site www.peaktopeakbatiks.com. When not working in his shop he enjoys live music, traveling, cooking and being outdoors in the Colorado mountains.

THOMAS MOORE (1779-1852) was an Irish poet who wrote the words for some of the best-loved songs in the English language including "The Last Rose of Summer." Although he wrote much light, serious and satirical verse, today he is remembered mostly for his verse set to music. In his day his works were as widely read as those of Lord Byron and Sir Walter Scott.

GEORGE MORRISON (1919-1999) was an Ojibwe Native American painter and sculptor. His studio was in Grand Marais, Minnesota on the shores of Lake Superior. Looking out on the ever-changing lake, he received spiritual inspiration from the interconnection between the air, the water, and the horizon. He continually experimented with new forms and materials in his construction of totem poles, coffee table tops and cubes. His connection with

nature is reflected in one of the names his cousin received for him in a dream: "Standing on the Northern Lights."

VLADIMIR NABOKOV (1899-1977) was a Russian emigrant who began writing in English in his forties. The author of *Lolita*, he is undoubtedly one of the most brilliant writers of the twentieth century. Nabokov was born into the Russian nobility but the family fortune was lost when they made their way into exile due to the 1917 Bolshevik Revolution. The role of the exile and the importance of memory are themes recurring in his work.

JACK NORWORTH (1879-1959) was a vaudeville entertainer and song writer. While riding a New York subway train in 1908, he saw a sign that said, "Ballgame Today at the Polo Grounds." He had never been to a baseball game, but the lyrics just popped into his head for one of the most popular songs in America, "Take Me Out to the Ballgame."

ALFRED NOYES (1880-1958) was one of the most popular English poets during his lifetime. He wrote ballads and romantic lyrics about English history, the sea, and sea voyages and was able to impart a sense of the majesty of the raging seas.

TROY PAIVA (1960-) is a free-lance product designer and illustrator working predominately in the toy industry for such major corporations as Hasbro and Mattel. He picked up photography as a way of letting the creative juices flow without being accountable to anyone. He still experiences that sense of awe which he had as a boy,

poking around boarded-up relics of the industrialized twentieth century in our southwestern deserts, only now he is taking pictures using the light of the full moon. The positive response to his "Last America Night Photography" has been overwhelming.

SAMUEL PALMER (1805-1881) created his most intense works, a series of tiny landscape paintings and drawings, in Shoreham, Kent, England. He was a devotee of William Blake. Pastoral scenes, with a distinctly rising moon partially hidden by billowing white clouds, are infused with heightened reality which makes them seem almost sacred. Palmer defined his landscapes as visionary because they transformed nature. "Only the artistic imagination could illuminate the hidden mysticism and poetry in nature," he wrote.

TONI PAWLOWSKY (1957-) lives in Madison, Wisconsin with her three sons, Jason, Justin, and Jared. Her background is in illustration and commercial art. Her work is represented by The Fanny Garver Gallery (Madison, Wisconsin) and Atomic Studios at atomicstudios@kookykool.com.

ARNA RENNAN (1954-) is a Duluth, Minnesota musician and "romantic impressionist" who interacts with the powerful stimulus of nature with her paints. Combining the wealth of tradition and her own personal approach, Arna's focus is to heighten the ordinary to the viewer's consciousness. She received her training at the National Academy of Art in Oslo, Norway and studied under Alf Jorgen Aas. At the end of his teaching career, he imparted this quote: "If you believe that there is nothing new under the sun, then you have no business being an artist—yet it is the same moon that shines on all lovers."

WENDY ROUSE (1958-) is a Duluth, Minnesota watercolor artist who is inspired by the daily sights around her such as family and friends, home and gardens. Underneath the representational subjects is a more abstract concern for life, as in the cycle of the seasons, the growth of plants, and the role human beings play in our universe. Ms. Rouse is fascinated by the transparency of watercolor which suggests that things may not be what they seem to be.

HENRI ROUSSEAU (1844-1910) was a self-taught French artist who painted some of the most unusual paintings of the early 20th century. As a child, Rousseau wanted to become an artist, but with the modest means of his working class family, that was nothing but a distant dream. Until he was 49, he collected custom fees from local farmers at a toll station after which he retired on a small pension to become a full-time painter— supplementing his income as a street musician and violin instructor. He depicted an imaginative, dream-like world with sharp details and bright, bold colors and influenced the emerging surrealism movement.

OSHIMA RYOTA (1718-1787) was a Japanese haiku writer who lived in Edo (the old name of Tokyo.) In Japanese, Oshima Ryota means "splendidly stout." Ryota avoided the urbane style of haiku writing prevalent in the mid-eighteenth century and was instrumental in promoting a return to the basic principles of

Bashō: a respect for the greatness of nature's power. He was an excellent teacher and is said to have had over 2,000 students at one time.

NONOGUCHI RYUHO (1595-1669) was a Japanese painter and poet. He was the forerunner for an artistic style called "haiga" in which haiku verses are included in a painting. Born in Kyoto, he called himself "Hmaya." The name originates from the family doll business. Ryuho studied under several famous masters and then established his own school and published many books including *Haika'i Hokkucho*.

SUGINO SAMPU (1647-1732) was a wealthy Japanese merchant who sold live fish. He gave a house to his esteemed teacher, Bashō. Sampu incorporated into his poetry Bashō's sense of the mystical connection between nature and man.

SAPPHO (c.625 B.C.-570 B.C.) was the premier female poet of antiquity. She is considered by some to be the greatest poet of all time. Her vivid, emotional style has influenced poets through the ages. Born into the nobility on the island of Lesbos in the Aegean Sea, her work was collected in nine books in the third century B.C. but only about 1000 lines have survived. The bishop of Constantinople in 350 A.D. ordered her writings to be burned. Since the late nineteenth century, fragments have been recovered from papyrus finds in Egypt. Her lyrical poems are very personal— usually about love and its attendant emotions.

WILLIAM SHAKESPEARE (1564-1616), the most widely known author in all English literature, was the son of a glover. At age eighteen he married Anne Hathaway, a woman eight years his senior, who bore him a daughter Susanna and twins, Hamnet and Judith. Shakespeare was a member of a company of actors who formed a syndicate to build and operate a new playhouse which was named the Globe. In his great plays such as *King Lear*, he devoted himself with unparalleled insight to exploring the nuances of human nature.

PERCY BYSHE SHELLEY (1792-1822), one of the great English lyric poets, rejected all conventions that he believed stifled love and human freedom. He felt truth could be understood by imagination as opposed to traditional Christian views. He abandoned his first wife and married Mary Wollstonecraft, the author of *Frankenstein*. Many times he forecast his death by drowning. At the age of thirty, he was at work on a long powerful poem, "The Triumph of Life," when his boat was caught in a storm and he and his son were found washed up on the shore near Leghorn, Italy by his good friend Lord Byron.

IZUMI SHIKIBU (c. 974-aft. 1033) wrote during the only Golden Age in literary history in which women writers were the predominant geniuses—Japan's Heian era. Her brief poems serve as clear windows into universal human emotions. She came from a lesser branch of the powerful Jujiwara clan and was married to a man as old as her father who already had many wives. When she was widowed in 1005, she went to court as an attendant to the

Empress Shoshi. Shikibu's works include a novel, a memoir and a collection of 128 poems.

MERLON SMITH (1941-) is a professional photographer from Silver Bay, Minnesota. Mentored by Space Shuttle photographer James Long and the late Lief Ericksenn, Smith pioneered special effects photography with his photos of nineteen Space Shuttle missions using star, rainbow, and mirage filters. His work is displayed in locations such as the Kennedy Space Center and the Minnesota State Capitol. He has received numerous awards and is currently focusing his attention on scenic photography.

SODO (1648-1723) was born in Yamanashi, China. His family name was Yamaguchi. When he was around forty years old, he became a disciple and patron of the great Basho.

ROBERT LOUIS STEVENSON (1850-1894) contacted tuberculosis as a child and struggled with the disease his entire life. He was born in Scotland where he wrote *Treasure Island*, *A Child's Garden of Verses* and *The Strange Case of Dr. Jekyll and Mr. Hyde*. After a number of unsuccessful visits to European spas, he came to Saranac Lake, New York and wrote *The Master of Ballantrae*. Stevenson spent the last five years of his life living as a planter in Samoa where he died from consumption.

MARY STEWART (1916-) is a writer of mysteries. She is recognized for her superb characterizations and her creation of exciting suspense. She has written a trilogy which is considered a classic in the genre of Arthurian legends focusing on Merlin, the wizard. Two of her acclaimed books are *The Moon-Spinners* and *Thornyhold*.

KARL FRIEDRICH THIELE (1780-1836) was a German printer who used a form of etching called aquatint. His most famous work is "The Starry Hall of the Queen of the Night," which is based on a stage design by Karl Friedrich Schinkel (1781-1841), a highly gifted architect and painter of spectacularly detailed landscapes. Schinkel made hundreds of stage settings for plays and operas—the most well known are those he created for Mozart's "The Magic Flute." The setting for the "Queen of the Night" shows the moment in Act I when, accompanied by thunder and a darkening stage, she makes her splendid appearance as a crescent moon within a star-filled dome.

HENRY DAVID THOREAU (1817-1862) was an American writer whose famous essay "Civil Disobedience" influenced reformers from Mahatma Gandhi to our present day civil rights activists. Unlike most writers of his time, he came from a working class family. His father made pencils and his mother took in boarders. For two years Thoreau lived alone in a cabin on the shore of Walden Pond near Concord, Massachusetts. His book *Walden* is a recounting of his experiences of living in harmony with nature.

EDWARD HOVELL-THURLOW (1781-1829) was an English writer who inherited the title of baron. His poem "Moonlight" was printed in 1814.

MARK TWAIN (1835-1910) is the pen name of Samuel Langhorne Clemens. This American humorist, newspaperman, lecturer and writer had little formal schooling and became a Mississippi steamboat pilot. He took his pen name from river slang for "two fathoms deep." He was unsurpassed as a creator of characters, most importantly Huck Finn. Twain introduced colloquial speech into American fiction. Ernest Hemingway said that modern American literature "begins with *Huckleberry Finn.*"

VINCENT VAN GOGH (1853-1890) was born in the Netherlands. He received no recognition during his lifetime and sold only one painting. He failed in every career he attempted and felt lonely and friendless throughout his life. Through his painting he tried to express his strong religious feelings and his need for love. He often went without food in order to give generously to the poor. He suffered from epilepsy, finally committing suicide when he was thirty-seven years old. His strong brush strokes and brilliant use of color make him one of the most beloved impressionist artists.

WALT WHITMAN (1819-1892) was an American journalist and poet whose poems sing the praises of democracy. In his preface to the first edition of *Leaves of Grass*, he wrote: "The United States themselves are essentially the greatest poem." When *Leaves of Grass* became popular, he was dismissed from his government job for having written an immoral book. One of his most popular poems "When Lilacs Last in the Dooryard Bloom'd" was written upon the death of Abraham Lincoln as his coffin was transported from Washington, D.C. to Springfield, Illinois.

HELEN MARIA WILLIAMS (1761-1827) was an English writer educated by her mother. As she matured, she became an avid supporter of the French Revolution and knew many of its leaders including Napoleon Bonaparte. She was imprisoned because of her enthusiasm for the Revolution and French culture but was eventually freed and naturalized as a French citizen. Her most famous writings involve France's revolutionary movement.

JAN HARTLEY WISE (1941-) is a professional artist and workshop instructor. Nourished by her deep affinity with the natural world, her images arise from dreams, from shamanic journeys, and from her connection to the collective unconscious. Wise's business, Wise Counsel, offers spiritual direction, shamanic healing, and workshops to people exploring their spirituality. Her work is represented by galleries in Ely, Grand Marais, and Duluth in Minnesota; Washburn, Mercer, Boulder Junction, and Spooner in Wisconsin; and in Iron River, Michigan.

WILLIAM BUTLER YEATS (1865-1939) is considered by many to be the greatest poet of the twentieth century. He was born in Dublin into the Irish Protestant middle class and received no formal education until he was eleven. Yeats had a passionate interest in mysticism and in Gaelic folklore and heritage. He was awarded the Nobel Prize for Literature in 1923. He is buried in his beloved County Sligo where his tombstone is engraved with the unforgettable epitaph which he composed: "Cast a cold Eye / On Life, on Death. / Horseman, pass by!"

CAROLE ZAKRZEWSKI (1978-) was born in Elmira, New York. She is a Smith College graduate now living in Northampton, Massachusetts. Her interests include permaculture, sustainable living, crafting, and culture jamming. She is a "self-styled creative goddess who reads, writes, and makes art with reckless abandon."

SHIBATA ZESHIN (1807-1891) began learning the rigors of lacquer craft as an eleven year old when he started his apprenticeship in Tokyo, Japan. By the end of his life he had exhibited his work in international exhibitions. His rigorous training as an artisan/ craftsman gave him the skills to understand the physical properties and potential of a variety of materials. His unparalleled technical skill imbues his paintings and lacquers with traditional Japanese humor, energy and grace. His subject matter comes from nature or Japanese legends and history.

ZI YE (6th-3rd century B.C.) is a collection of popular Chinese folk songs. This collection was traditionally thought to have been written by a single female poet from that period. The "yes" of the song "I could not sleep" has a mysterious, moving power.

ACKNOWLEDGEMENTS AND SOURCES

Grateful acknowledgements is made for permission to reproduce the following works:

ART

Page 12: "The Magic Flute. Set design for the entrance of the Queen of Night," print, by Karl Friedrich Thiele, German (1780-1836), after Karl Friedrich Schinkel (1781-1841). Accession Number 54.602.I (14). Used by permission of The Metropolitan Museum of Art, New York, N.Y.

Page 15: "Isis Protecting the Pharaoh," bas-relief sculpture, Temple of Isis/Corbis.

Page 18: "The Starry Night," oil on canvas, 29 x 36 1/4, by Vincent van Gogh (1853-1890). Acquired through the Lillie P. Bliss Bequest (492.19). Museum of Modern Art, New York, N.Y., USA. Digital Image ©The Museum of Modern Art/Licensed by SCALA/Art Resource, NY.

Page 24: "Moonlight Evening at Shinagawa (Shinagawa Mikoshi no Tsuki)" by Kobayashi Kiyochika, Japanese, (1847-1915), from the series 'One Hundred Views of Musashi Province' (Musashi Hyakkei), Meiji period, 1884, woodblock print, 35.5 x 23.6 cm, The Clarence Buckinghan Collection, 1936.232, Image ©The Art Institute of Chicago.

Page 27: "The Sleeping Gypsy," 1897, oil on canvas, 51" x 6' 7" (129.5 x 200.7 cm), by Henri Rousseau. The Museum of Modern Art, New York. Gift of Mrs. Simon Guggenheim. (646.1939). Photograph ©1999 The Museum of Modern Art, New York. Licensed by SCALA/Art Resource, NY.

Page 51: "Spectator: Busa Fragment," 1984, paper collage, by George Morrison. Collection of the Tweed Museum of Art, University of Minnesota, Duluth, Alice Tweed Tuohy Foundation and Patron and Subscribers Purchase Funds.

Page 60: "Old Moon," ca. 1940, lithography, by John S. DeMartelly. Collection of the Tweed Museum of Art, University of Minnesota, Duluth, Gift of Jonathan Sax.

Page 66: "Two Men Contemplating the Moon," oil on canvas, 1819-1820, by Casper David Friedrich. AKG London.

Page 72: "Cornfield by Moonlight, with the Evening Star," c. 1830, watercolor by Samuel Palmer. The British Library/Heritage-image Partnership.

Page 81: "Vence: Goat," 1960, oil on canvas, by Marc Chagall. ©Christie's Images/Corbis.

Page 84: "Autumn Grasses in Moonlight," right panel screen, by Shibata Zeshin, Japanese (1807-1891). Accession Number 1975.268.137. Used by permission of The Metropolitan Museum of Art, New York, N.Y.

Page 16: "The Creation," (excerpt), by James Weldon Johnson, from *God's Trombones* by James Weldon Johnson, ©1927 by The Viking Press, Inc.

Pages 20 & 51: "Lullaby" and "After Many Springs" by Langston Hughes, *The Collected Poems of Langston Hughes*, ©1994 by the Estate of Langston Hughes. Used by the permission of Alfred A. Knopf, a division of Random House, Inc.

Pages 25 & 26: "Full Moon" and "Silver" by Walter de la Mare, from *Collected Poems*, 1901-1918, by Walter de la Mare, ©1920, by Henry Holt and Company, Inc. ©1948, by Walter de la Mare.

Page 26: "I Gazed Upon the Cloudless Moon" by Emily Brontë, from *The Cherry Tree*, edited by Geoffrey Grigson (The Vanguard Press, 1962).

Pages 31 & 79: "Look--" (translated by Robert Hedin) and "Moon and Apple" (translated by Robert Bly) by Rolf Jacobsen, from *The Roads Have Come to an End Now: Selected and Last Poems* of Rolf Jacobsen, Copper Canyon Press, ©2001. Reprinted by permission of Robert Hedin, Robert Bly, and Copper Canyon Press.

Page 31: "The Moon is distant from the Sea--," (excerpt) by Emily Dickinson from *The Poems of Emily Dickinson*, Thomas H. Johnson, ed. (Cambridge: The Belknap Press of Harvard University Press). ©1951, 1955, ©1979 by the President and Fellows of Harvard College.

Pages 46 & 52: "who know if the moon's" and "the moon looked into my window" by e.e. cummings from *Complete Poems: 1904-1962* by e.e. cummings, edited by George J. Firmage. ©1926, 1954, ©1991 by the Trustees for the E. E. Cummings Trust. ©1985 by George James Firmage. Used by permission of Liveright Publishing Corporation.

Page 49: "The Cat and the Moon" by William Butler Yeats from *The Collected Works of W. B. Yeats*, edited by Richard J. Finneran. ©1940 by Georgie Yeats, © renewed 1968 by Bertha Yeats, Michael Butler Yeats, and Anne Yeats. Reprinted with permission of Scribner, an imprint of Simon & Schuster Adult Publishing Group and A. P. Watt Ltd.

Page 56: "Voyage to the Moon" by Archibald MacLeish, ©1969 by The New York Times Company.

Page 68: "Ktsi Manido Great Spirit Moon" by Joseph Bruchac from *No Borders* (Holy Cow! Press, 1999), ©1999 by Joseph Bruchac. Used by permission of Holy Cow! Press.

Page 92: "The Moving Tides," excerpt, by Rachel L. Carson, from *The Sea Around Us*, ©1950, 1951 by Rachel L. Carson. Reprinted by permission of Oxford University Press, New York.

SELECTED SOURCES

The Moon-Spinners by Mary Stewart (Ballentine Books, 1962).

The Earth Speaks: An Acclimatization Journal, edited by Steve Van Matre and Bill Weiler (The Institute for Earth Education, 1983).

To the Moon! Coedited by Hamilton Wright, Helen Wright and Samuel Rapport (Meredith Press, 1968).

Moonscapes by Rosemary Ellen Guiley (Prentice Hall Press, 1991).

The Essential Haiku: Versions of Basho, Buson, & Issa, edited by Robert Hass (Ecco Press, 1994).

An Introduction to Haiku by Harold G. Henderson (Doubleday, 1958).

The Book of the Moon by Tom Folley (Courage Books, 1997).

The Arbuthnot Anthology of Children's Literature, complied by May Hill Arbuthnot (Scott, Foresman and Company, 1961).

Buck Moon. Mead Moon. Moon When Cherries Are Ripe. Moon of the Giant Cactus. Sun House Moon. Corn Tassel Moon. Buffalo Rutting Moon. Ripe Moon. Rain Moon. Trees Broken Moon. Advance in a Body Moon. Whale Moon. Red Salmon Time Moon. Go Home Kachina Moon. Moon of Claiming. Crane Moon. Moon of the Middle Summer. Hungry Ghost Moon. Lightning. August: Corn Moon. Grain Moon. Dog's Day Moon. Woodcutter's Moon. Sturgeon Moon. Green Corn Moon. Wart Moon. Red Moon. Moon When Cherries Turn Black. Moon of the New Ripened Corn. Blackberry Patches Moon. Collect Food for the Winter Moon. Wheat Cut Moon. No Snow on Trails Moon. All the Elk Call Moon. Autumn Moon. Berries Ripen Even in the Night Moon. Summertime Moon. Lightning Moon. Women's Moon. Dog Days Moon. Dispute Moon. No Snow in the Road Moon. September: Harvest Moon. Full Corn Moon. Fruit Moon. Drying Grass Moon. Barley Moon. Moon When the Calves Grow Hair. Cool Moon. Spawning Salmon Time Moon. Ripe Choke Cherries Moon. Leaf Yellow Moon. Spider Web on the Ground at Dawn Moon. All Ripe Moon. Corn in the Milk Moon. Salmon Spawning Moon. Moon without a Name. Moon of the Black Calves. Moon When Plums are Scarlet. Big Feast Moon. Little Wind Moon. Moon When Calves Grow Hair. Mulberry Moon. Chrysanthemum Moon. October: Hunter's Moon. Dying Grass Moon. Moon When Water Freezes. Blood Moon. Moon of the Changing Season. Moon When Water Begins to Freeze on the Edge of the Stream. Travel in Canoes Moon. Corn Ripe Moon. Deer Rutting Season Moon. Great Sandstorm Moon. Leaf Fall Moon. Falling River Moon. Falling Leaves Time Moon. Basket Moon. Big Wind Moon. Kindly Moon. Blackberry Moon. Moon When Beading and Quilling is Done. November: Beaver Moon. Frosty Moon. Snow Moon. Moon of the Falling Leaves. Autumn Time Moon. Killing Deer Moon. Corn Harvest Moon. Every Buck Loses His Horns Moon. All Gathered Moon. Stomach Moon. Snowy Mountings in the Morning Moon. Freezing Moon. Initate Moon. No Name Moon. White Moon. Dark Moon. Sassafras Moon. December: The Long Night Moon. Christmas Moon, Christ's Moon. Moon Before Yule. Oak Moon. Moon of the Popping Trees. Her Winter Houses Moon. Night Moon. Cold Month Moon. Ashes Fire Moon. Turning Moon. Middle Winter Moon. Big Freezing Moon. Cold Moon. Twelfth Moon. Bitter Moon. Peach Moon.

January: Winter Moon. Yule Moon. Wolf Moon. Old Moon. Moon of Frost in the Teepee. Cold Weather Moon. Ice Moon. Her Cold Moon. Hoop and Stick Game Moon. Man Moon. Trees Broken Moon. Younger Moon. Limbs of Trees Broken by Snow Moon. Moon when the Little Lizard's Tail Freezes Off. Play Moon. Moon of the Terrible. February: Snow Moon. Hunger Moon. Storm Moon. Trapper's Moon. Moon of Dark-Red Calves. Black Bear Moon. Black Bear Moon. Budding Time Moon. Elder Moon. Wind Moon. Running Season Moon. Wind Moon. Running Season Moon. Frightened Moon. Raccoon's Rutting Season Moon. No Snows on Trails Moon. No Snow in the Road Moon. Moon of Ice. Moon when Trees Pop. Bony Moon. Trapper's Moon. Little Famine Moon. March: Lenten Moon. Full Crust Moon. Sugar Moon. Full Worm Moon. Crow Moon. Full Sap Moon. Fish Moon. Worm Moon. Chaste Moon. Moon of Snow-blindness. Light Snow Moon. Flower Time Moon. Seventh Moon. Big Clouds Moon. Lizard Moon. Little Sandstorm Moon. Wind Strong Moon. Earth Cracks Moon. Moon When Juice Drips from the Trees. Little Wind Moon. Cactus Blossom Moon. Death Moon. Chaste Moon. Sleepy Moon. Moon When Eyes Are Sore From Bright Snow. Big Famine Moon. April: Sprouting Grass Moon. Egg Moon. Seed Moon. Eastern Moon. Planter's Moon. Pink Moon. Fish Moon. Spring Moon. Moon of Grass Appearing. Do Nothing Moon. Deep Water Moon. Ashes Moon. Little Frogs Croak Moon. The Eighth Moon. Leaf Split Moon. Leaf Spread Moon. Grease-wood Fence Moon. Big Wind Moon. Awakening Moon. Growing Moon. Wildcat Moon. Peony Moon. Moon When Geese Return in Scattered Formation. May: Milk Moon. Mother's Moon. Hare Moon. Flower Moon. Corn Planting Moon. Moon When the Ice Goes Out of the Rivers. Ninth Moon. Moon When Horses Get Fat. Moon of the Shedding Ponies. No Name Moon. Moon to Get Ready for Plowing and Planting. Salmonberry Bird Moon. Too Cold to Plant. Dragon Moon. Panther Moon. June: Full Rose Moon. Honey Moon. Rose Moon. Flower Moon. Moon of Making Fat. Strawberry Moon. Hot Moon. Moon When the Buffalo Bulls are Rutting. Salmon Fishing Moon. Berry Ripening Season Moon. Ripening Strawberries Moon. Rotten Moon. Corn Moon. Turning Moon. Leaf Dark Moon. Flower Moon. Hoeing Corn Moon. Plant Moon. Turning Back Moon. Moon of Horses. Windy Moon. Lotus Moon. July: Thunder Moon. Hay Moon.